W9-BGA-913

The Kunsthistorische Museum Vienna

The Treasury
and the Collection
of sculpture and
decorative arts

Manfred Leithe-Jasper

Director
of the Treasury
and the Collection of sculpture and decorative arts

Rudolf Distelberger

Curator
Collection of sculpture and decorative arts

Vienna

The Kunsthistorische Museum

Scala/Philip Wilson

© 1982 Philip Wilson Publishers Ltd and Summerfield Press Ltd
Russell Chambers, Covent Garden, London WC2E 8AA

Text: Manfred Leithe-Jasper and Rudolf Distelberger
Translated from the German by Elsie Callander and Ilse Seldon
Photographs: Fotostudio Otto
Design: Alan Bartram
Edited by Philip Wilson Publishers Ltd
Series Editor: Judy Spours

Produced by Scala Istituto Fotografico Editoriale, Firenze
Phototypeset by Tradespools Limited, Frome, Somerset
Printed in Italy

ISBN 0 85667 137 1

FRONT COVER: *Saliera* (salt-cellar) by Benvenuto Cellini, 1540–3
BACK COVER: Crown of the Emperor Rudolf II, Imperial Court
Workshop, Prague, 1602

Contents

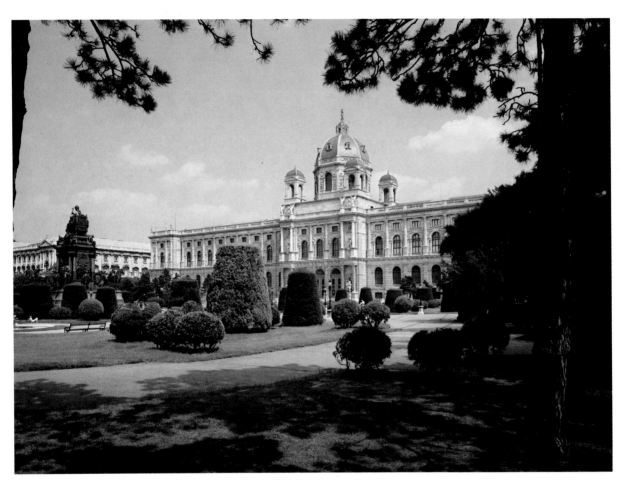

Exterior view of the Kunsthistorische Museum.
The buildings were constructed after plans
by Carl Hasenauer and Gottfried von
Semper, 1871–91.

The Treasury

The Collection of sculpture and decorative arts

Abbreviations in captions
Diam = diameter
D = depth
H = height
L = length
W = width

The Museum inventory numbers for each object
depicted are given in parentheses at the end of captions.

The Treasury
Manfred Leithe-Jasper

Introduction

The title 'Art Historical Museum' embraces both the collections from many spheres and periods of European art and culture and the Museum building itself, which can claim to be an edifice of the highest architectural interest.

Since the beginning of the nineteenth century, plans had been made in Vienna to transfer the collections of the Imperial Court, which had previously been inadequately housed in various sections of the Imperial Palace and the Castle Belvedere, to a central site in the city for exhibition as a self-contained unit. The erection of two museum buildings of identical external form opposite each other, to house the Natural History Museum and the Art Historical Museum, finally brought about the geographical separation of the natural history objects from the artifacts of the Imperial collections. Although Karl Haase had won an architectural competition for the building, it was Gottfried von Semper, who, by decisively changing the latter's plans, really gave the buildings their solemn, monumental character. The sumptuous interior, however, is the work of Karl Hasenauer, whose talents lay unmistakably in decorative art. The most outstanding artists of Austria took part in the work, such as the painters Munkácsy, Makart, and Klimt, and the sculptors Tilgner and Weyr. The precious materials used in the decoration contributed further to the achievement of a desired brilliance and to the creation of an appropriate framework for the priceless works of art, which were to find a permanent home here after centuries of Imperial patronage. As a result of connecting the Museums and the Court mews lying to the west with the Castle, which was also enlarged at this time, to the Court churches and the Court library, as well as the Court theatres situated a short distance away behind the Court Gardens, an 'Imperial forum' was created. This 'forum' continued the old tradition of the universality of the Imperial Court embracing all spheres of life, and indeed was able for the first time to show this in monumental fashion.

The actual building of the Museum was begun in 1871; and on 17 October 1891 it was inaugurated by the Emperor Franz Josef. The Egyptian and Far Eastern Collection, the Antiquities Room, and the Collection of sculpture and decorative arts are now housed on the upper ground floor. The main exhibits of the Paintings Gallery are displayed on the first floor, while the secondary Collection takes up the second floor of the south wing, and the Coin Room the north wing. For reasons of space, the Collection of weapons, consisting of the combined stocks of the Imperial armoury and the Court hunting store, had already been moved over before the First World War to the new wing of the Hofburg, the Imperial Palace, to which the Collection of old musical instruments, and recently also the stock of the old antique collection from Ephesus, was transferred. The Treasury remained in the old Hofburg. In the mews section, where the

Emperor Karl vi had already once installed the Paintings Gallery in 1728, pictures and sculpture of the nineteenth and twentieth centuries were exhibited in a display in what was called the 'New Gallery' in 1967. These had come from the stocks of the Paintings Gallery and the Collection of sculpture and decorative arts. Also in the Hofburg is the costume section, a fine collection of former Court clothes and uniforms. The Wagenburg, a Collection of historical carriages and harnesses mainly from the Court—formerly housed in the Court mews— has been exhibited since 1921 in the Winter Riding School of the Castle of Schönbrunn. Finally, the Art Historical Museum has had an annexe for the last few years in the Castle of Ambras near Innsbruck, which consists of a *Kunst-* and *Wunderkammer* (art and treasure chamber), an armoury, and the temporary exhibition of historical portraits of Austria.

A brief glance at the history of the collections of the Art Historical Museum shows that their character largely bears the mark of the personalities of individual collectors. Although the Museum was only inaugurated towards the end of the last century, the tradition of Hapsburg collecting goes back to the Middle Ages, at least as far as Emperor Ferdinand in 1564, and is to be found continuously recorded in inventories of various collecting fields. It was only in the following generations, however, that famous collectors exerted an influence which really bore the stamp of the Hapsburg collections. The most noteworthy of these figures is Archduke Ferdinand I, who had already, as Governor of Bohemia and especially as Regent of Tirol and the Austrian forelands, developed extensive and mainly historical collecting and installed his famous *Kunst- und Wunderkammer* in the Castle of Ambras. His 'Heroes' Armoury', for which he published the first printed collection catalogue (which, however, did not appear until six years after his death in 1601) forms the basis of the present collection of weapons, the richest and most varied armoury in the West. The Art Room at Ambras constitutes, along with the stocks taken over from the Treasury, the basis of the Collection of sculpture and decorative arts.

Ferdinand's nephew, the Emperor Rudolf I (reigned 1576–1612) ranks as one of the greatest patrons and collectors known in Europe. Not only did he establish one of the most important collections of all time in his residence in Prague, but he also inherited the Ambras Collection from the heir of Archduke Ferdinand II for the House of Hapsburg, thus securing its continuity. He was one of the most committed collectors of the paintings of Albrecht Dürer, Pieter Breughel the Elder, and Correggio, which are still the glory of the Paintings Gallery today. To the same extent as he collected older works of art did he overwhelm the artists of his time with commissions. The style of objects from the highly productive Court workshops in the spheres of stone-carving and goldsmith's art is still essentially to be found in the collections of the Treasury and

sculpture and decorative arts. The greater part of this unique collection had in fact reached Vienna before Sweden invaded Prague at the end of the 30 Years War, plundering whatever treasures remained there.

Apart from Rudolf II, the Paintings Gallery has another Hapsburg founder: Archbishop Leopold Wilhelm, the younger brother of the Emperor Ferdinand III, who was Governor General in the Hapsburg Netherlands from 1646 to 1656. The important acquisitions that he had managed to make there brought the Gallery its unique richness of seventeenth-century Flemish and Italian paintings, and especially of sixteenth-century Venetian paintings.

With his passion for collecting, Archduke Leopold William was, however, something of an outsider from his family in his century, since they had turned increasingly to the representative arts, music and the theatre, and had been seized with a veritable passion for building in the late seventeenth and early eighteenth centuries. Along with a heightened need for prestige, this must also have been the real motivation of Emperor Karl VI in the 1820s for the first very comprehensive decorative exhibition in the Paintings Gallery in the Castle mews. Then his daughter, the Empress Maria Theresa (reigned 1740–80), had the Treasury re-arranged in 1750. She was also responsible for the acquisition of great altar works by Rubens, Van Dyck, and Caravaggio in the Netherlands. Her son, Emperor Josef II (reigned 1780–90), ordered the transfer of the Paintings Gallery from the mews to the Upper Belvedere Castle, where for the first time it was arranged systematically from an art history standpoint, and found a place in keeping with its importance. Joseph II was an enlightened monarch and decreed that it should be open to the public.

The reign of Emperor Franz II (1792–1835), the last Emperor of the Holy Roman Empire, coincided with the classical period; not surprisingly, it was the Antiquities Room that benefited from considerable additions. It also coincided, however, with one of the most troubled political phases of European history, the time of the French Revolution. The Ambras Collection had been brought to Vienna for security reasons and was exhibited in the Lower Belvedere; at the same time the treasure of the Order of the Golden Fleece from Brussels and the Imperial jewels from Aachen and Nürnberg had also found refuge in Vienna from the army of Napoleon.

During the reign of Emperor Franz Josef (1848–1916) there was in Vienna—unlike London, Paris, Berlin, and New York—no large-scale collecting activity. It was rather the re-arrangement and re-organization of the Hapsburg artistic estate that was the outstanding event in the history of collecting, an event which had its temporary zenith in the combining of nearly all the holdings in the splendid and purpose-built Art Historical Museum.

At the end of the First World War and after the ensuing disintegration of the Austro-Hungarian monarchy, the republic of Austria took over the artistic estate of Hapsburg-Lorraine. This heritage had first to be defended against unjustified claims by the States succeeding the Austro-Hungarian Empire, a defence which was not always, but mainly, successful. As a result of the breakup of the Court, the Art Historical Museum once more received significant additions. The Treasury and tapestry collection were now incorporated and put under the direction of the Collection of sculpture and decorative arts. At this point the costumes and carriages sections were also added, and finally the art collection of the Austrian Este line, most of which stemmed from the collection of the Marquis Tommaso degli Obbizzi in the castle of 'Il Catajo' near Padua, which was divided between the Antiquities Room, the Collection of sculpture and decorative arts, and the new Collection of musical instruments which was then founded. In 1932 the Museum was endowed with yet another important bequest: it is to this legacy from the Viennese industrialist Gustav von Benda that the Collection of sculpture and decorative arts is indebted for the very precious works of the Florentine Renaissance.

The Second World War did not spare the Art Historical Museum, which suffered severe bomb damage. The contents of the collections had fortunately for the most part been evacuated and were brought back with very few losses after the War. Purchases and occasional bequests are still added to the collections even today, but large-scale acquisition is no longer financially possible. However, the tremendous historical head-start that had been achieved in earlier centuries more than makes up for this. Thus the Art Historical Museum, in spite of its chequered history, which at the same time bears witness to a rare continuity, remains one of the leading museums of the world.

View of the sculpture collection before the
foundation of the Kunsthistorische Museum.

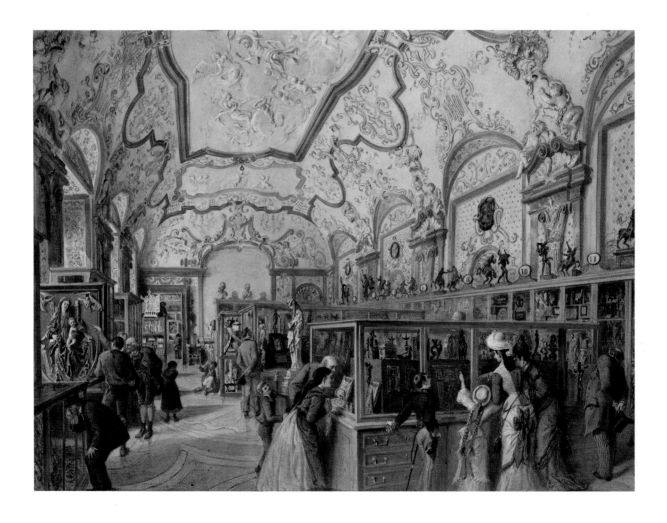

The secular Treasury

Although it is true that the objects in the secular Treasury came from the medieval treasure of the Hapsburgs, the history of this collection did not by any means proceed in a straight line but often by very tortuous and not always reconstructable paths. This was the result of frequent divisions of inheritances in the various lines, especially in the Middle Ages and the Renaissance. Since, however, the oldest line of the house of Hapsburg at the time always possessed the central Austrian States and later also Hungary and Bohemia, this treasure was gradually concentrated in the capital, Vienna, the Imperial residence. So it has always been possible to prove the existence in Vienna, in unbroken tradition from the time of Emperor Ferdinand I (born in 1564), of a Treasury, which since the seventeenth and eighteenth centuries, when considerable holdings from the Prague art room of Emperor Rudolf II and from the Graz art room of the younger Styrian line were added, increasingly developed into an art collection. Under the Empress Maria Theresa, this Treasury was re-established in 1750 in the place where it is still to be found today and in the display cases which have still for the most part been retained. After the death of her husband, Emperor Franz Stefan of Lorraine, in 1765, she also arranged for the private diamonds to be placed in the Treasury, which by the standards of the time were immensely precious. Finally, the treasure of the Order of the Golden Fleece from Brussels and the Imperial jewels from Nürnberg and Aachen were rescued from the conquering armies of Napoleon and the French Revolution and brought to Vienna between 1794 and 1797. They were deposited in the Treasury at the behest of Franz II, the last Roman Emperor, in 1800, and thus the collection attained its largest dimensions and greatest splendour. On the occasion of the proclamation of Austria as an Empire in 1804, the Imperial Dynastic Crown of the Hapsburgs became the official crown of the new Empire, and the private family Treasury became a collection of the highest political importance. Consequently, when a radical re-arrangement of, and new inventory for the Hapsburg art possessions took place between 1871 and 1891, Franz Josef ordered that the Treasury holdings should be split: the Royal insignia and family souvenirs and jewels remained in the Treasury, whilst all other objects were joined together with the other family collections and taken to the newly erected Art Historical Museum to be exhibited. At the time of the breakup of the monarchy at the end of the First World War, the family jewellery, which ranked as private possessions, and the diamond treasure of the Imperial family were taken with them into exile, but the Treasury was joined to the Art Historical Museum as a separate collection under the same administration as the sculpture and decorative arts. In 1938 Hitler had the Imperial jewels transferred to Nürnberg. After that the Treasury was closed and re-established and re-opened only in 1954, when the Imperial jewels had been restored to Austria.

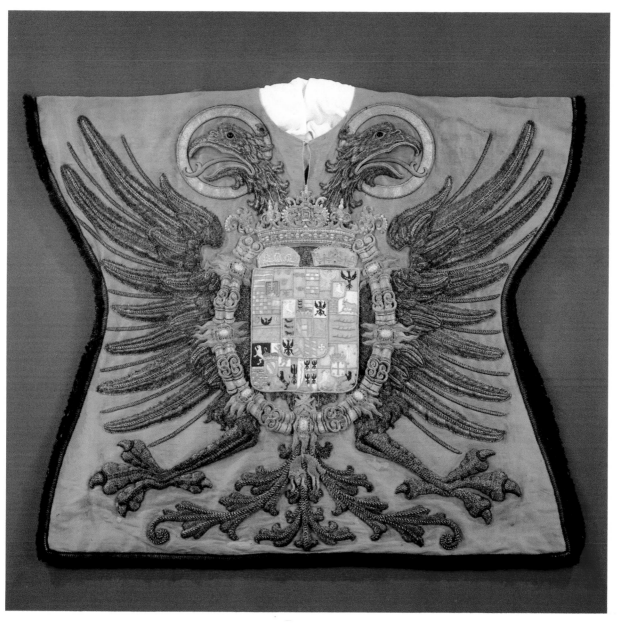

TABARD OF THE HERALD OF THE ROMAN EMPEROR
Matthias Helm and Christoff Rauch,
Prague (?), 1613
Gold cloth, black silk, and coloured
embroidery
The coat of arms of Emperor Matthias on the
breast plate was replaced by that of Emperor
Leopold II in 1790, at the time of the latter's
coronation. (XIVS/100)

The insignia of the Austrian hereditary homage

The departure point and basis of the abundant power of the House of Austria were the Duchy and later the Archduchy of Austria with which the Roman King Rudolf of Hapsburg invested his two sons, Albrecht and Rudolf, after the victorious battle against King Ottokar of Bohemia in 1278. Here, as in the other 'hereditary lands' belonging to the Hapsburg sphere of power, the enthroning of the monarch was not accomplished by his coronation as in Hungary and Bohemia, which were later also Hapsburg kingdoms, but through the ceremony of hereditary homage, by which the estates that were represented in the State Parliaments swore allegiance to the ruler, while the latter swore to respect their rights. Nevertheless, royal insignia were used even in this ceremony: the Austrian Archduke's hat, which is kept in the monastery of Klosterneuburg in accordance with the foundation privilege of 1616, and was at the disposal of the ruler for the ceremony of homage, an orb and a sceptre. The estates were represented by 'hereditary offices' going back to the old Court offices, which had their own insignia and were handed down from generation to generation in the noblest families.

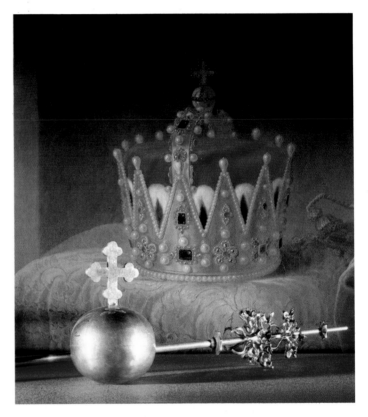

IMPERIAL ORB AND SCEPTRE FROM THE INSIGNIA OF THE AUSTRIAN HEREDITARY HOMAGE
Bohemian (?) orb second half of 15th century, sceptre mid-14th century
Silver-gilt; *H* 16 cm *L* 80 cm respectively
Having originally formed part of the Bohemian coronation regalia, the orb and sceptre were incorporated into the Austrian hereditary insignia by Emperor Matthias. The background shows a Baroque copy of the Austrian Archduke's coronet. (XIV/43/44)

▷
FEUDAL SWORD (SWORD OF INVESTITURE)
Hans Sumersperger, 1496
Blued steel, inlaid in gold, brass, silver and mother-of-pearl; *L* 139 cm
This ceremonial sword came from the private Coronation robes of the Emperor Maximilian I, and bears the coats of arms of his territorial possessions. (XIV/4)

HOUND'S COLLAR, FALCONRY BAG, FALCON LURE,
AND FALCON HOODS
The insignia of the Grand Master of the
Imperial Hunt and the Grand Master of
Imperial Falconry
Vienna, 1835
Green velvet, embroidered in gold; silver gilt;
red leather (XIV/36–40)

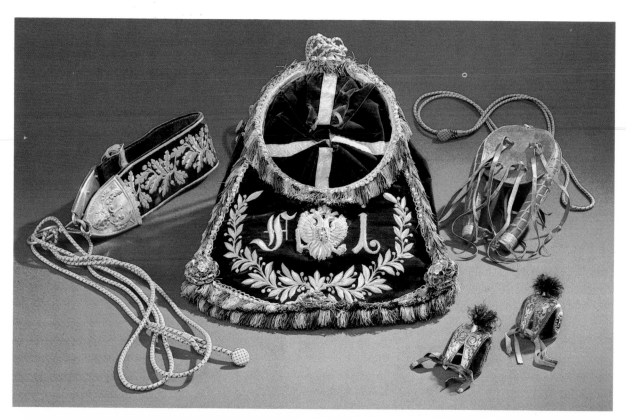

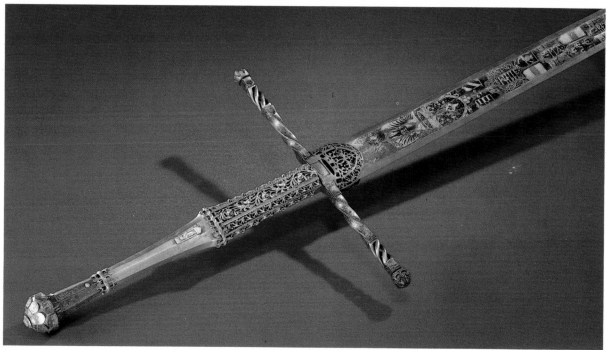

The insignia and jewels
of the Holy Roman Empire

The insignia and jewels of the Holy Roman Empire can perhaps be described as some of the most venerable and splendid monuments of Western history, for they are the symbol of an idea of rulership which began with the coronation of Charlemagne on Christmas Eve 800 and lasted till the year 1806, when the Emperor Franz II dissolved this Empire under the pressure of the superior power of Napoleon. For medieval man at least, the Imperium Romanum lived on in the Holy Roman Empire under the rule of Christ, which explains the coexistence of secular and spiritual or theological representation in the insignia and the multiplicity of important religious relics among the jewels. The relics ranked as a divine pledge of lawful rule on earth which started with Christ by virtue of his sacrifice on the Cross, and whose representative the Emperor now was. This was particularly true of the great Cross particle and of the Holy Lance, into which, in keeping with tradition, a nail from Christ's Cross had even been worked, and which in all probability Pope Hadrian, in a reference to Constantine the Great, had presented to Charlemagne. As a result, this token of power became a link between the Imperium Romanum of Constantine and the later Holy Roman Empire of Charlemagne. The consequence of this and the ensuing coronation was that Charlemagne was accorded great respect as the first Western Emperor, and that three jewels, which according to legend came from his grave, were regarded as 'relics of Charlemagne' and their presence at coronations showed a wish to establish a direct visible and legal link between the first Western Emperor and the one who was about to be crowned. The new Emperor took the coronation oath on the Imperial book of Gospels, a Carolingian royal manuscript; the *Stephansbursa* (bursa of St Stephen), a reliquary of the ninth century, no doubt originating from Rheims, in which earth soaked in the blood of the first martyr St Stephen was preserved, was worked into the seat of the throne; and the Emperor was girded during the coronation with the 'sabre of Charlemagne', a ninth-century East-European work.

The main item of the insignia, however, was the Crown. It was probably made for Emperor Otto II, possibly in the Benedictine Abbey of Reichenau which was in the forefront of artistic achievements in the second half of the tenth-century. Here again a complicated theological sequence symbolizes the transcendental character of world dominion as it was understood in the Middle Ages. The ground-plan of the heavenly Jerusalem was conceived as octagonal, and thus the Crown was cast in similar form, the twelve great precious stones of the frontal band symbolizing the twelve apostles, in juxtaposition to whom in the Old Testament stand the twelve tribes of Israel, while the iconography of the four enamel bands refers to the coronation liturgy. In the Ottonian period close contacts existed with the East Roman-Byzantine Empire, so the arch may go back to the plumed arch of the Roman Imperial helmet. Out of these formal interlacings emerged the unique, recognizable form of the Crown, which is clearly distinguished from all other Western crowns.

Also unique is the set of coronation robes belonging to the Imperial jewels. Apart from the *Adlerdalmatik* (eagle dalmatic) and the *Stola* (stole), all the pieces come from the coronation vestments for the most part made by Arabian artists in the twelfth and thirteenth centuries for the Norman kings of Sicily. They eventually reached Friedrich II by way of inheritance and through him were added to the Imperial treasure.

With the exception of the three 'Aachen pieces', which were preserved in the Aachen Cathedral treasury, the insignia and jewels of the Holy Roman Empire were primarily at the immediate disposal of the Emperors and were kept by them in fortified castles. This old tradition was not broken until 1424, when Emperor Sigismund placed the treasure under the protection of the free city of Nürnberg, in order to preserve it from the attacks of the Hussites.

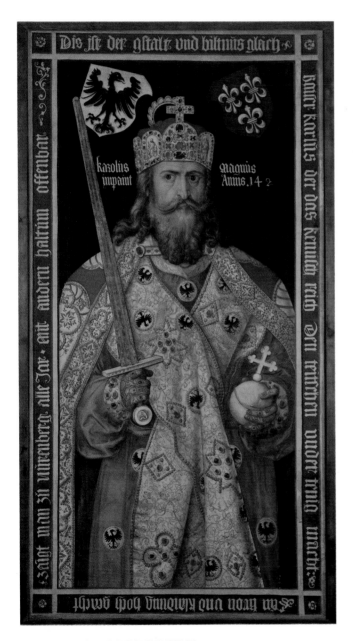
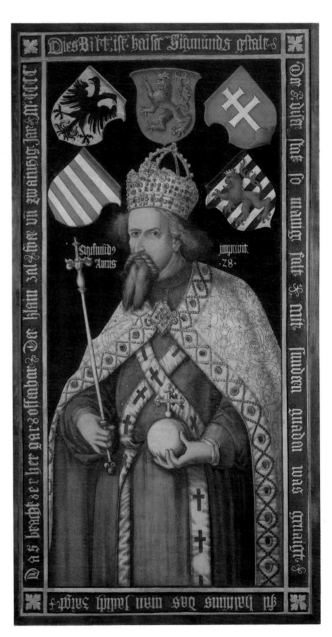

EMPEROR CHARLEMAGNE AND EMPEROR
SIGISMUND
**After Albrecht Dürer's idealized portraits,
Nuřnberg *c* 1600**
Oil on canvas
Charlemagne is considered the founder of the
Holy Roman Empire. In 1424 Sigismund
transferred the custody of the Imperial insignia
to the Free Imperial City of Nürnberg, in
whose hands it remained until 1796. (GG 2770/
2771)

IMPERIAL ORB

West German (Cologne?), last quarter of 12th century

Gold, gold filigree, precious stones, and pearls; *H* 21 cm

The first evidence available of an orb being used in a coronation ceremony dates from 1191, when Pope Coelestin III, in accordance with the wishes of Emperor Heinrich VI, handed the latter the Imperial orb in addition to the other insignia. (XIII/2)

SCEPTRE AND ASPERGILLUM (SPRINKLER)

German, sceptre second third of 14th century, aspergillum *c* 1300

Sceptre: parcel-gilt silver; *L* 61.5 cm
Aspergillum: silver; *L* 58.5 cm

Sceptre and aspergillum, a liturgical accessory, are the insignia of the secular, but originally also the sacred, office of the Emperor. (XII/3 and XIII/4)

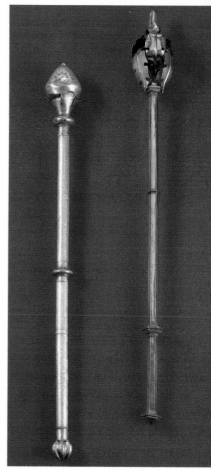

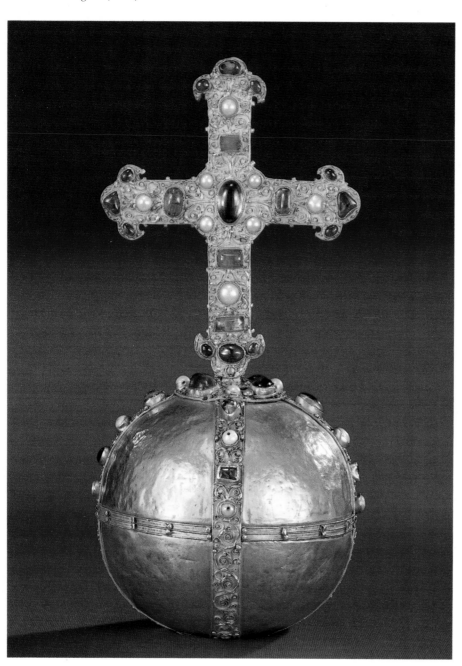

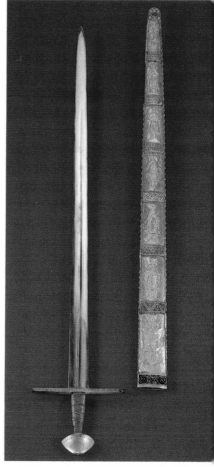

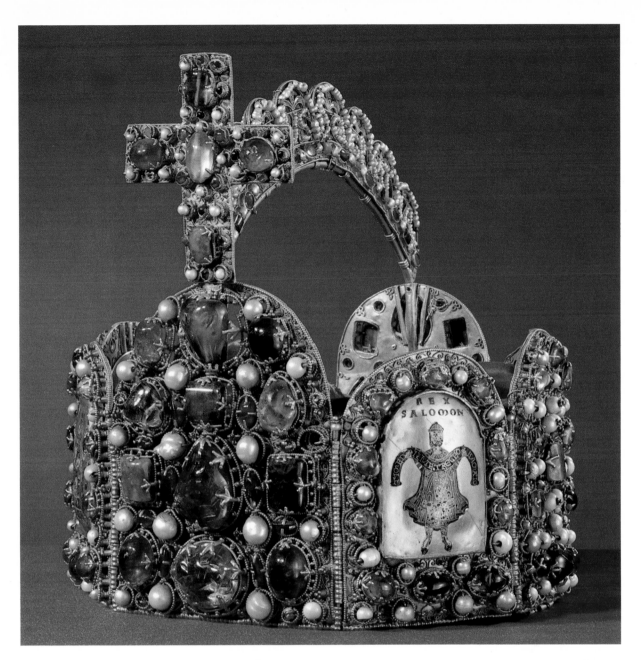

◁

IMPERIAL SWORD

**The scabbard German, first half of 11th
century; the sword between 1198 and 1218,
later restored**

Sword: blade steel, pommel and cross-bar
silver-gilt, hilt bound with silver wire
Scabbard: olive wood, gold, enamel, garnets,
and formerly pearls; *L* 110 cm

The pommel bears the Imperial Eagle and the
coat of arms of King Otto IV (of Brunswick,
reigned 1198–1218). It has the inscription
BENEDICTVS DO(MINV)S DE(V)S.QVI.DOCET
MANVS. The cross-bar has the inscription
+CRISTVS:VINCIT: CRISTVS REINAT and CRISTVS
VINCIT:CRISTVS REIGNAT:CRIST(VS) INPERAT.
In the coronation procession the sword bearer
carried the sword, point upwards, in front of
the Emperor. (XIII/17)

△

IMPERIAL CROWN

**West German (Reichenau?), second half of
10th century with later additions**

Gold, gold filigree, various precious stones,
pearls, and enamel; *H* approx 25.5 cm

It is now thought that the crown was made for
Emperor Otto II in the years 978/980. The
cross as we see it today dates from the time of
Heinrich II (d 1024), the arch from that of the
latter's successor, Konrad II (d 1039). (XIII/1)

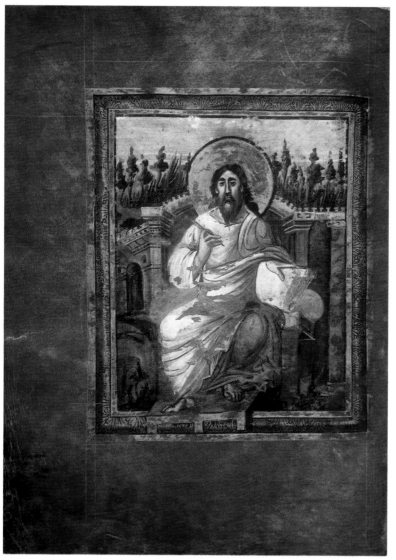

THE IMPERIAL BOOK OF GOSPELS: THE GOSPEL OF ST
JOHN

Manuscript: Aachen, end of 8th century
Purple-dyed parchment, gold, silver, and
watercolour; 32.4 × 24.9 cm
Cover: Hans von Reutlingen, Aachen, *c* 1500
Silver, silver-gilt, precious stones, and red
velvet; 34.5 × 26.1 cm
At the coronation, the future ruler took the
oath of allegiance on this Gospel, raising his
fingers and touching the first page of the
Gospel of St John. (18)

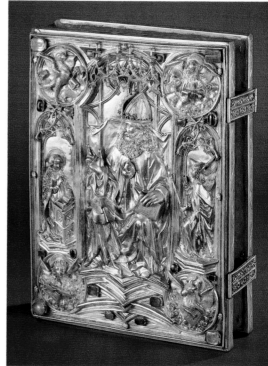

Eastern Europe, end of 9th or beginning of 10th century

Sabre: blade steel with gilded copper inlay; wood, fish-skin, gold, silver-gilt, and precious stones; *L* 90.5 cm

Scabbard: wood, leather, gold; *L* 86.5 cm

It was earlier thought that the sabre was a present to Charlemagne from Harun al Raschid or part of the Emperor's booty from the Avarsi campaign. It was with this sabre that the monarch was girded at the coronation. (XIII/5)

Aachen, beginning of 9th century with 15th-century additions

Gold on a wooden core, precious stones and pearls, the reverse silver-gilt; *H* 32 cm

This reliquary is said to have contained earth saturated with the blood of St Stephen, the first martyr. (XIII /26)

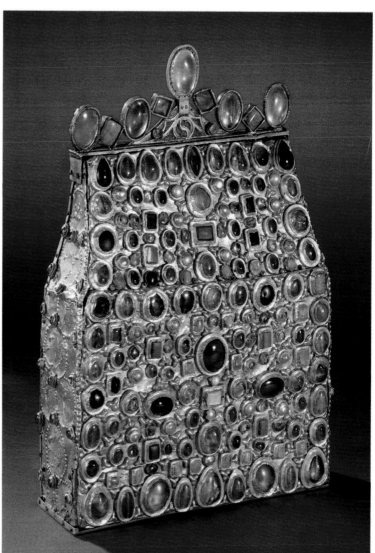

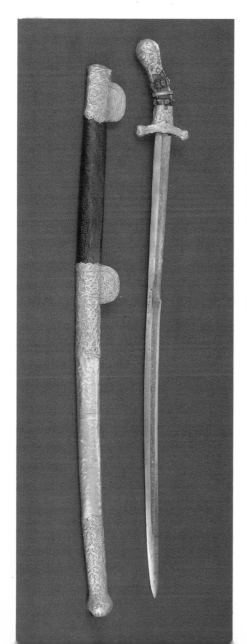

IMPERIAL CROSS

West German, *c* 1024, the base 1352
Oak, gold, precious stones, pearls, and niello
Base: silver-gilt and enamel; *H* overall 94.3 cm
It was in the Imperial cross that the Imperial
relics were originally kept; the Holy lance in
the transverse arm, the particle of the Holy
Cross in the shaft (XIII/21)

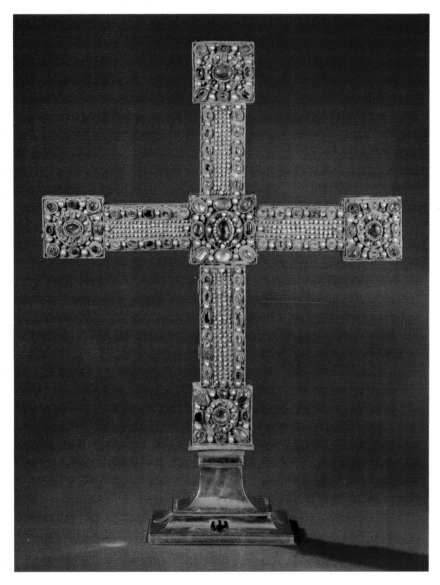

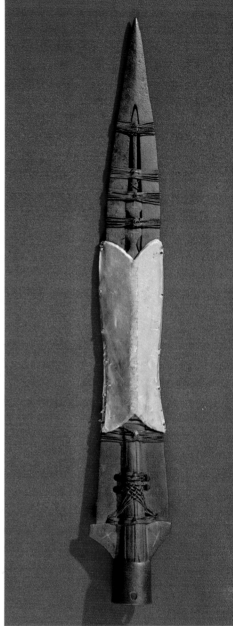

▷

RELIQUARY WITH THE CROSS PARTICLE
Setting German, 14th century
Wood: Pinus nigra Arnold or Pinus sillvestris L;
gold; *H* 31 cm
The Cross particle was originally kept in the
Imperial Cross and was probably given its gold
setting in the form of a processional cross in
the reign of the Emperor Karl IV. The leather
case was made in Nürnberg in 1517. (XIII/20)

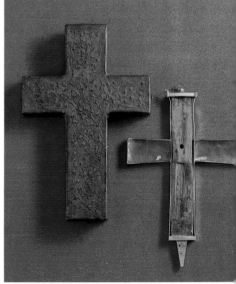

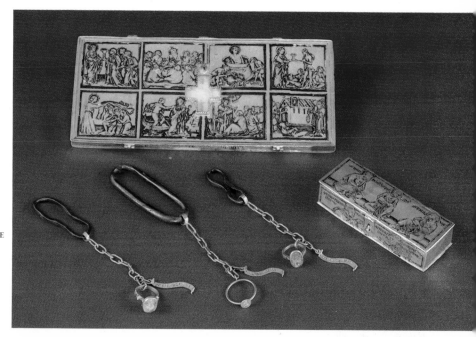

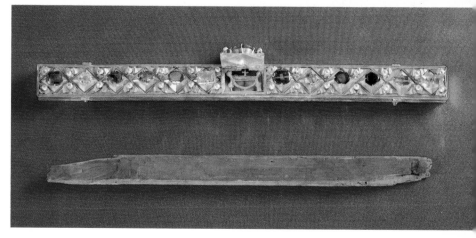

HOLY LANCE

Langobardian-Carolingian, 8th century
Steel, iron, brass, gold, silver, and leather;
L 51 cm
A pointed oval opening was chiselled out of
the blade of the lance, into which a carefully-
forged ornamental iron pin was fitted, which
was thought to be a nail from the Cross of
Christ. The blade of the lance was broken
before the year 1000, and Heinrich IV
ordered a silver band to be made to mend it; in
the reign of Karl IV it was given a gold sleeve.
It is thought that the lance was originally in the
possession of Charlemagne, then of Rudolf of
Burgundy. Between 926 and 935 it came into
the possession of Heinrich I and through him
it became part of the Imperial treasure. At that
time it was held to be the lance of St Mauritius,
but later on it was revered as the lance with
which Longinus opened the side of Christ. The
victory of Otto I over the Hungarians in the
Battle of Lechfeld (the plateau between the
rivers Lech and Wertach) in 955 was
attributed to its miraculous powers. (XIII/19)

▷

RELIQUARY CONTAINING A FRAGMENT OF THE ROBE
OF ST JOHN THE EVANGELIST AND RELIQUARY
CONTAINING THE LINKS OF THE CHAIN

Avignon or Prague, between 1368 and 1378
Gold and niello; 24.8 × 15 × 1.3 cm,
12.5 × 4.7 × 2.8 cm respectively
The links of the chain are said to be pieces of
the iron chains with which the Apostles John,
Peter, and Paul were bound in prison. Pope
Urban V presented the Emperor Karl IV with
these relics in 1368.

RELIQUARY CONTAINING A FRAGMENT FROM CHRIST'S CRIB

Venice, c 1340–50 or Prague, c 1368–78
Gold, precious stones, and pearls; 49 × 41 × 2.1 cm
Pope Urban V presented the Emperor Karl IV with this relic in
1368. The goldsmith's work is reminiscent of that of Paolo
d'Oro in Venice. (XIII/24)

CORONATION ROBE
Palermo, Royal workshop, 1133/4
Red silk, embroidered in gold; gold filigree,
enamel, precious stones, and pearls; W 342 cm
The Cufic inscription in Arabic round the hem
states that the robe was made in 1133/4 by
Arab artists for King Roger II of Sicily. It came
into the possession of the Emperor Friedrich II
with the Sicilian inheritance. It is thought that
he incorporated the robe into the Imperial
treasure after his coronation in Rome in 1220.
(XIII/14)

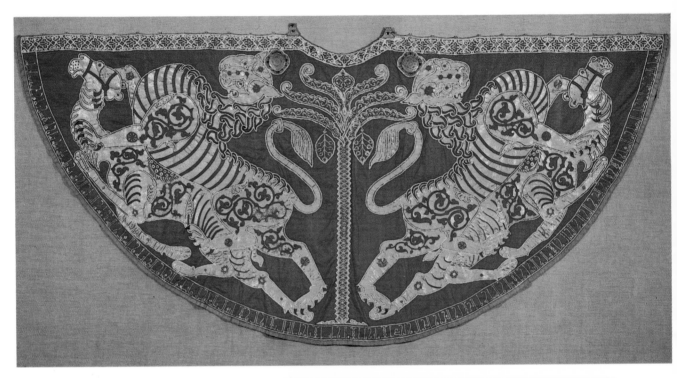

TWO RELIQUARIES CONTAINING FRAGMENTS OF THE
TABLECLOTH USED BY CHRIST AND OF CHRIST'S
APRON
Hans Krug the Younger; Nürnberg 1518
Silver gilt, precious stones and pearls;
H 55.5 cm (*right*), H 55 cm (*left*) (XIIIS/22 and 23)

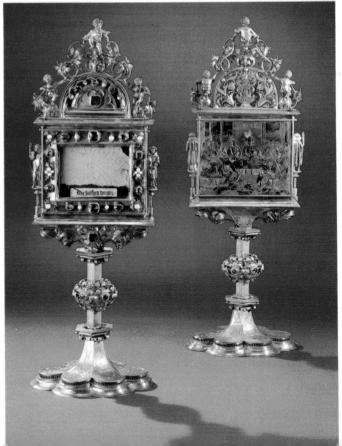

DALMATIC
Palermo, Royal workshop, between 1130 and 1154
Purple silk with trimmings in red silk, embroidered in gold; gold filigree, enamel, and pearls; *H overall* 141 cm (XIII/6)

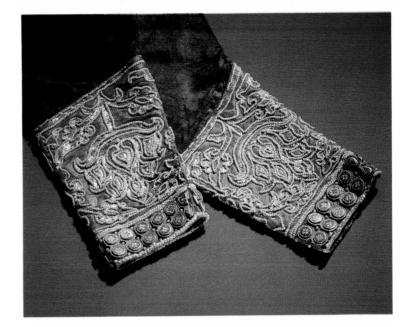

GLOVES
Sicily, beginning of 13th century
Red silk, embroidered in gold; rubies, sapphires, pearls; gold and enamel; *L* 15.5 cm and 17 cm respectively
The gloves were presumably made for the Emperor Friedrich II before 1220, the year of his coronation, in the Royal workshop in Sicily. (XIII/11)

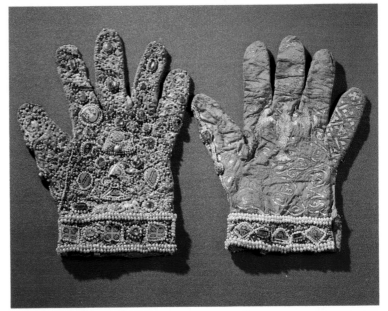

SHOES
Sicily, beginning of 13th century, altered in Nürnberg between 1612 and 1619
Calf with red silk and gold edging; precious stones and pearls; *L* 25.5 cm and 26 cm each
Like the gloves, these shoes were presumably made before 1220 for the Emperor Friedrich II. (XIII/13)

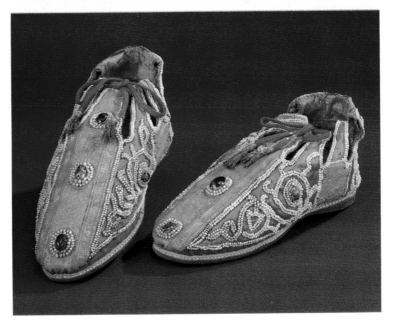

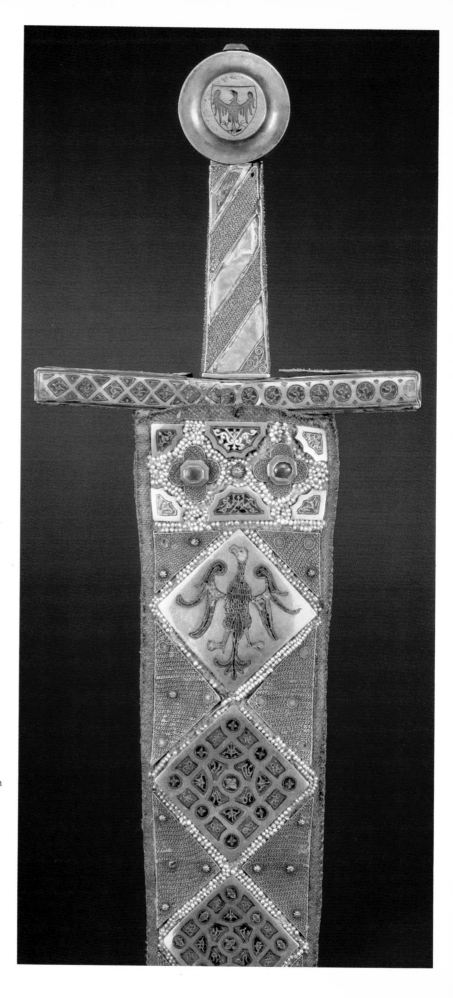

CEREMONIAL SWORD

Sicily, before 1220

The blade is made of steel; the hilt and cross-bar of wood with gold plaques faced with filigree and cloisonné enamel. The pommel, an addition dating from the time of Karl IV, is made of silver-gilt with the Imperial coat of arms, showing the Eagle, and the Bohemian coat of arms showing the Lion. *L* 108 cm

The wooden sheath is lined with parchment covered with linen; it has gold panels with enamel and gold filigree and is studded with precious stones and pearls.

From a set made before 1220 for the Emperor Friedrich II. This sword was later used when the Nürnberg envoy was knighted after the coronation. (XIII/16)

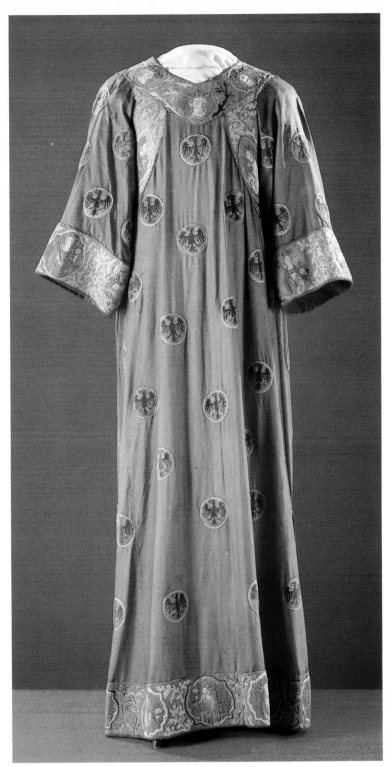

THE EAGLE DALMATIC
South German, first half of 14th century
Chinese purple damask, *c* 1300; gold and silk
embroidery
This dalmatic occasionally replaced the smaller
Tunicella. (XIII/15)

CASE FOR THE IMPERIAL CROWN
Prague, after 1350
Leather with rich partly-coloured tooling; iron
mounts; *H* 23 cm
Presumably made to the orders of the Emperor
Karl IV, as indicated by the coats of arms with
the Imperial Eagle and the Bohemian Lion.
(XIII/30)

The Austrian Empire

When Napoleon declared himself Emperor of the French, and in view of the increasingly obvious signs of the breaking up of the Holy Roman Empire as a consequence of Buonaparte's victory, Emperor Franz II proclaimed the hereditary Empire of Austria on 11 August 1804. This new Empire included all the territorial possessions of the Hapsburgs at the time, namely the hereditary Austrian territories plus the kingdoms of Hungary and Bohemia. After Napoleon's downfall, when a new European order was being determined at the Congress of Vienna, the Italian provinces which fell to Austria were united to form the Lombardo-Venetian kingdom, which was integrated into the new Imperial State. It was only at the time of the Austro-Hungarian agreement of 1867 that there ensued a division of the territories of the Hungarian St Stephen's Crown, the symbol of the State, from those of the Empire. This was when the Imperial and Royal double monarchy of Austro-Hungary emerged under the personal union of the Hapsburgs, the two halves united in the person of one sovereign.

The crown of Emperor Rudolf II, the so-called Imperial Dynastic Crown, became the official insignia of the new Imperial State in 1804 and remained after the introduction of the double monarchy as the insignia of the Austrian half of the Empire. St Stephen's Crown, which had been kept in Budapest, meanwhile became the official insignia of the kingdom of Hungary. The new Imperial State also took over the Hapsburg Orders of Merit, some of which had been found by the Empress Maria Theresa. They remained in existence until the end of the monarchy in 1918.

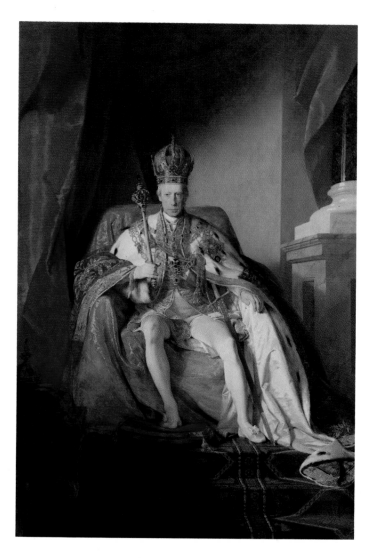

EMPEROR FRANZ I OF AUSTRIA IN THE AUSTRIAN IMPERIAL ROBES
Friedrich von Amerling, Vienna, 1832
Oil on canvas, 260 × 164 cm
Franz I is depicted in the robes of the Austrian Emperor. He wears the crown of Rudolf II of the House of Austria, which in 1804 became the official crown (insignia) of the Austrian Empire, as well as the ribbons of the four orders of the House of Austria: the Golden Fleece, the Order of St Stephen, the Leopold Order, and the Order of the Iron Crown, whose Grandmaster was the Emperor.
(GG 8618)

MANTLE OF THE AUSTRIAN IMPERIAL ROBES
Vienna, 1830; after a design by the Director of Scenery and Costumes of the Imperial Theatres, Philipp von Stubenrauch
Red velvet, gold embroidery, and ermine
(XIV/117)

THE CORONATION ROBES OF THE LOMBARDO-VENETIAN KINGDOM
Vienna, 1838; after a design by Philipp von Stubenrauch
Blue velvet, gold embroidery, ermine, white moiré silk, and lace; silver gilt
The robes were made for the coronation of Ferdinand I as King of Lombardo-Venetia, held in Milan in 1828. (XIV/118–120)

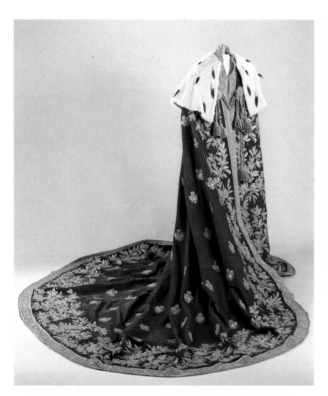

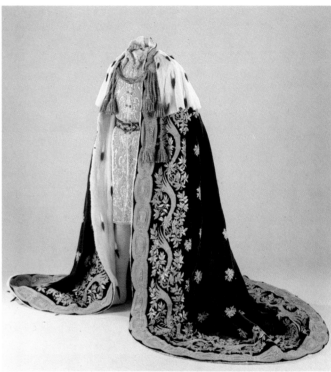

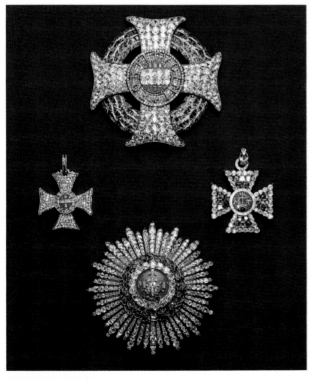

GRAND CROSS AND CROSS OF THE MILITARY ORDER OF MARIA THERESA AND THE STAR AND CROSS OF THE ORDER OF ST STEPHEN
Gold, silver, enamel, diamonds, emeralds, and rubies
To celebrate the Austrian victory over the Prussians near Kolin on 18 June 1757, the Empress Maria Theresa founded a military order of merit, which bore her name. On the occasion of the election of her son Joseph II as King of Rome in 1764 she founded the Order of St Stephen, which was the highest civil order of merit in the monarchy. (XIa 16, 17, 20 and 21)

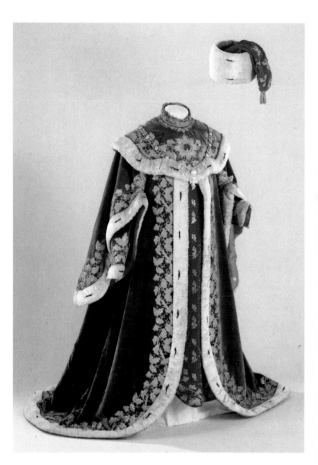

ROBES OF A KNIGHT OF THE HUNGARIAN ORDER
OF ST STEPHEN
Vienna, *c* 1764
Green and red velvet and imitation ermine,
with gold embroidery (III/StO-217)

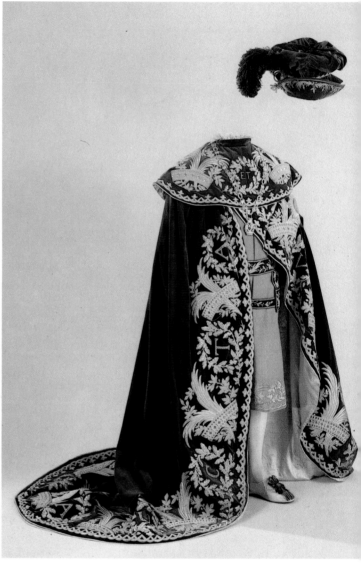

ROBES OF A KNIGHT OF THE AUSTRIAN ORDER OF
THE IRON CROWN
**Vienna, 1815; after a design by Philipp von
Stubenrauch**
Violet and orange velvet with silver
embroidery and white silk
The order was created by Napoleon and re-
founded by Austria on the occasion of the
establishment of the Lombardo-Venetian
kingdom in 1815. The emblem of the order is
the Iron Crown of Lombardy. (EK-2)

The dynastic treasure of Hapsburg-Lorraine

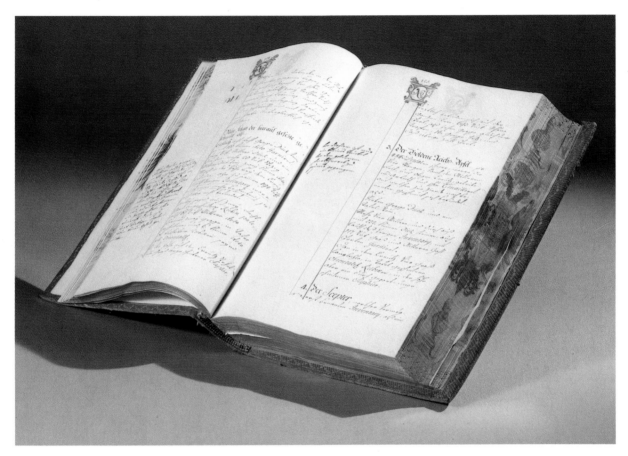

The dynastic treasure of Hapsburg-Lorraine is the family treasure of the House of Austria and hence constitutes the real nucleus of the secular Treasury. It was part of the entail of primogeniture of the Imperial Art Collections, which started with Ferdinand I. To the Hapsburg-Lorraine treasure belong the Imperial crown insignia which were formerly private and which became the official Austrian insignia in 1804, also a large holding of jewels, as well as the agate bowl and the so-called *Ainkhürn* (unicorn), the two inalienable heirlooms of the House, and also the baptismal objects and Christening robes and numerous keepsakes recalling individual members of the Arch-duchy. The latter include particularly those pieces connected with Napoleon I, Emperor of the French, and his second consort Louise, Archduchess and Imperial Princess of Austria and her son Napoleon Franz Karl, King of Rome and later Duke of Reichsstadt. Finally, they include those objects which stem from the possessions of the luckless Emperor Maximilian of Mexico, the younger brother of Emperor Franz Josef. This treasure was originally considerably bigger, because after 1871 all the art collections were joined together and exhibited in the Art Historical Museum, and only those objects which could provide a record of the power and greatness of the Imperial House by reason of their symbolic, historical, or material value were left in the Treasury.

THE TREASURY INVENTORY OF 1750
The inventory was established by the Empress Maria Theresa after the reorganization of the collections.

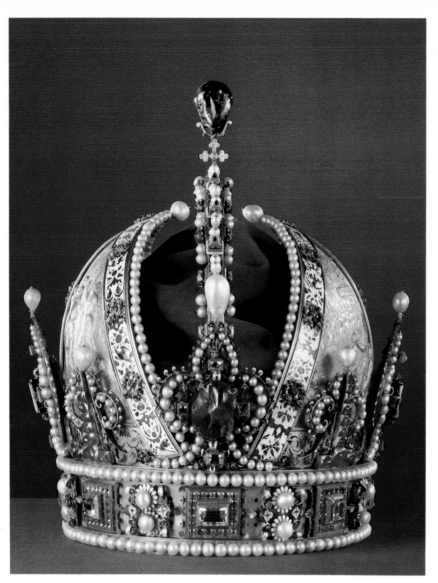

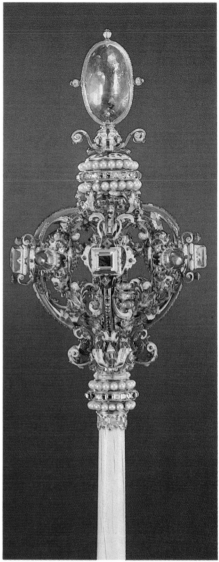

CROWN OF THE EMPEROR RUDOLF II

Prague, Imperial Court Workshop, 1602
Gold, enamel, table-cut diamonds, rubies, a single sapphire, and pearls; H 28.6 cm
This crown, one of the major works of the European goldsmith's art, was originally the private crown of the Emperor of the House of Hapsburg and became part of the official insignia of the Austrian Hereditary Empire in 1804. In it were combined the lily-circlet of the Medieval Royal crown with the arch of the Imperial crown and the bishop's mitre, the badge of sacred dignity. The Emperor was the only layman who had been granted the right to wear the mitre. (XIa 1)

△

AUSTRIAN SCEPTRE

Andreas Osenbruck; Prague, 1612–15
'Unicorn's horn' (in fact narwhal horn); gold, enamel, table-cut diamonds, rubies, a single sapphire, and pearls; L 75.5 cm
This sceptre, ordered by the Emperor Matthias replaced—together with the orb—the older Rudolfian insignia. These became part of the Bohemian Royal insignia, and the former Bohemian sceptre and orb became the Austrian Archducal insignia. (XIa 2)

▷

CROWN OF STEPHAN BOCSKAY AND CASE

Turkish, beginning of 17th century, cloth Persian, c 1600
Gold with niello, rubies, emeralds, turquoises, and pearls; H 23.5 cm
The crown had been sent to the Transylvanian usurper Stephan Bocskay by Sultan Ahmed I in 1605 as a token of Turkish recognition. However, the former had to hand it over to Archduke Matthias as a token of submission as early as 1606. (XIV/25 and 184)

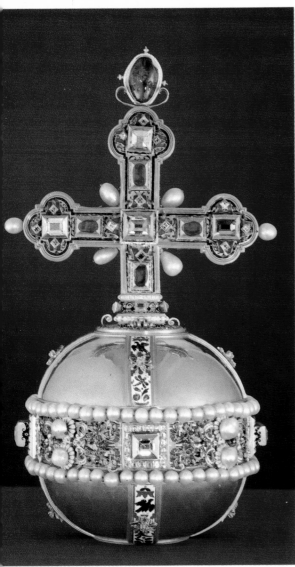

◁
AUSTRIAN ORB
Prague, Imperial Court workshop, after 1612(?)
Gold, enamel, table-cut diamonds, rubies, a single sapphire, and pearls; H 27.4 cm
The orb seems to have been made at a time between the crown and the sceptre. It has as yet not been possible to interpret the symbolic significance of the three strikingly large sapphires surmounting each of the three insignia. (xɪa 3)

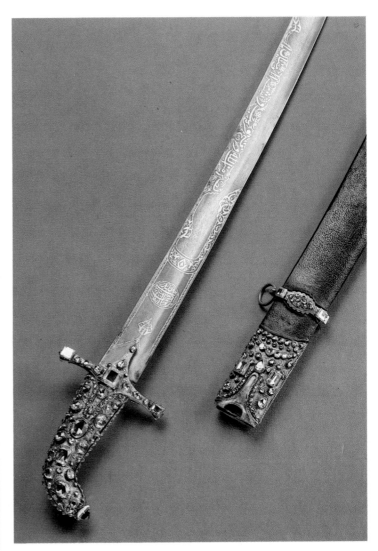

△
SABRE
Turkish, second half of 17th century, Austrian additions c 1712
Damascened steel; gold, silver, table and lozenge-cut diamonds; leather; L 91.5 cm
The inscription on the blade reads (in translation), IN THE NAME OF GOD, THE GENTLE ALL-MERCIFUL—HELP FROM GOD, VICTORY AND GLAD TIDINGS TO THE FAITHFUL. The silver ornaments and diamond decoration were added on the occasion of the coronation of the Emperor Karl VI as King of Hungary in 1712. (xɪa/50)

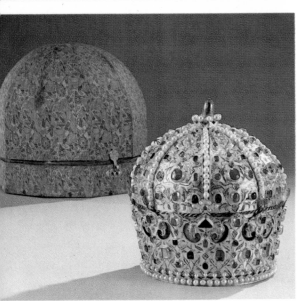

JEWEL CASKET OF EMPRESS MARIE LOUISE
Martin Guillaume Biennais, Paris, *c* **1810**
Silver-gilt, green velvet; 45.7 × 32.2 × 29.5 cm
According to tradition, Napoleon's wedding
present was handed to the Empress in this
case. The small table is after a design by the
Viennese architect Theophil Hansen between
1856 and 1880. (XIV/153)

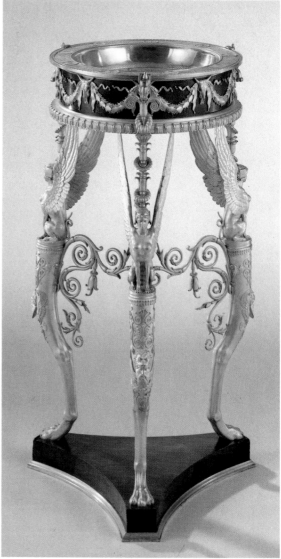

NAPOLEON FRANZ KARL, KING OF ROME, LATER
DUKE OF REICHSTADT
Jean-Baptiste Isabey, 1815
Watercolour; 15 × 11 cm
The picture was probably painted during
Isabey's stay in Vienna during the Congress of
Vienna. (XIV/150)

TRIPOD WITH BASIN
Luigi and Francesco Manfredini, Milan, 1811
Silver-gilt; lapis lazuli mounted on a brass core;
H 81.5 cm
This tripod, a copy of an antique bronze tripod
in the Museo Nazionale in Naples, was a
present from the city of Milan to the Empress
Marie Louise on the birth of her son. (XIV/152)

CRADLE OF THE KING OF ROME
**Jean-Baptiste Claude Odiot and Pierre
Philippe Thomire, Paris, 1811, after designs
by Pierre Paul Prud'hon**
Silver-gilt; mother-of-pearl, velvet, silk, and
tulle
The cradle was a present from the city of Paris
to Napoleon and his second wife, the Empress
Marie Louise, on the occasion of the birth of
their son Napoleon Franz Karl. (XIV/28)

VARIOUS CHRISTENING ROBES

Vienna, 1762 and 1830 respectively

Silver moiré with gold lace; cambric with gold
embroidery; pink silk, tulle, and lace

The little pink Christening robe was worn by
the babe who was later to become the Emperor
Franz Josef (*b* 1830), and by his siblings.
(XIV/10, 11 and A 208)

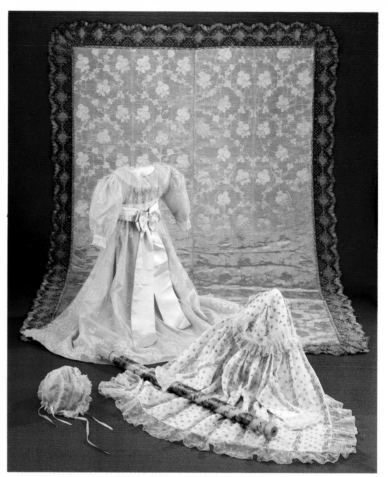

▽

SMALL EWER

**Prague, Imperial Court Workshop, beginning
of 17th century**

Gold, partly enamelled, and rubies; *H* 15.5 cm

This smaller ewer was used for Christenings
instead of the ewer from the Baptismal set,
which was too heavy. (XIV/7)

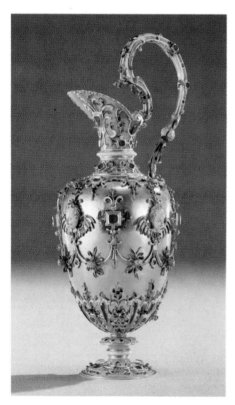

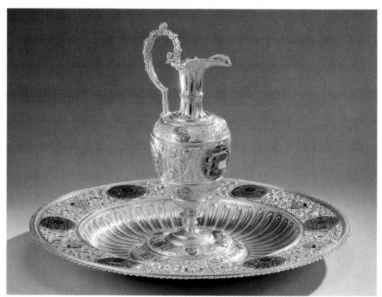

BAPTISMAL EWER AND BASIN

North Italian(?), 1571

Gold, partly decorated in enamel. *H* of ewer
34.5 cm; *Diam* of basin 61.5 cm

This set was a wedding present from the
Carinthian *Stände* (the different Estates) to the
Archduke Karl of Inner Austria and his wife
the Duchess Maria of Bavaria. It was used for
Christening ceremonies at Court as early as the
seventeenth century. (XIV/5 and 6)

AQUAMARINE
Setting _c_ 1600
Oriental aquamarine of 492 carats; gold
The aquamarine is mentioned 1607–11 in the
Kunstkammer of Emperor Rudolf II. (P1 1911)

VESSEL CUT FROM A SINGLE EMERALD
Dionysio Miseroni, Prague, 1641
Columbian emerald of 2680 carats from the
mines at Muzo; enamelled gold
This is the largest cut emerald in the world.
(P1 2048)

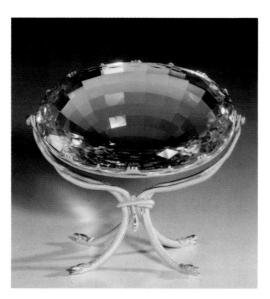

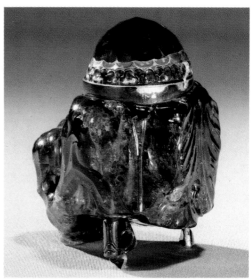

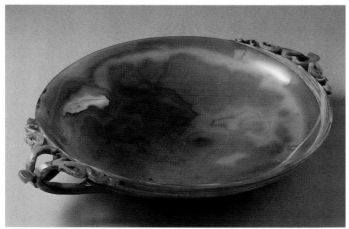

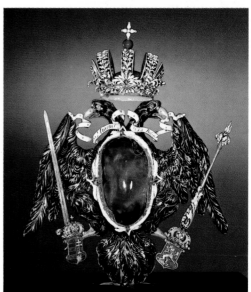

AGATE BOWL
Flabius Aristo, Trier, 4th century A.D.
Agate; _W_ 75 cm
This bowl, the largest of its kind, was believed
to be the Holy Grail. Because of a faulty
transcription, it was thought that the name of
Christ could be read in it. It was therefore held
to be so precious that in the Inheritance
Agreement of 1564 the bowl, together with
the _Ainkhürn_ was declared 'the inalienable
heirloom of the House of Austria'. (XIV/1)

HYACINTH (JACINTH) 'LA BELLA'
1687, set in an Imperial Double Eagle
Hyacinth (jacinth) of 416 carats; gold; silver-
gilt, and enamel (XIa/51)

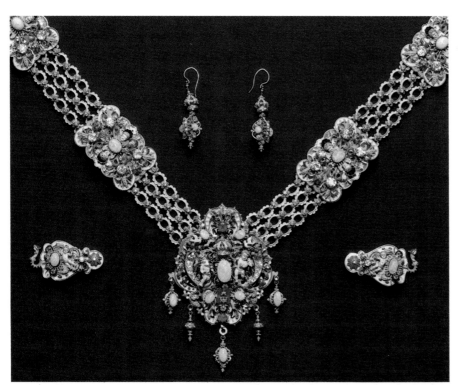

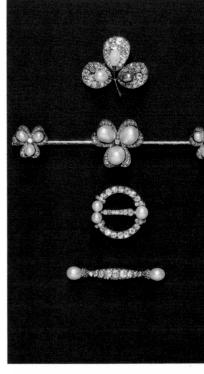

△

HUNGARIAN OPAL JEWELLERY
Egger Bros, Budapest, 1881
Gold, enamel; Hungarian opals, rubies, and
diamonds
Present from the City of Budapest to Princess
Stephanie of Belgium on her marriage to
Crown Prince Rudolf in 1881. (xib/41)

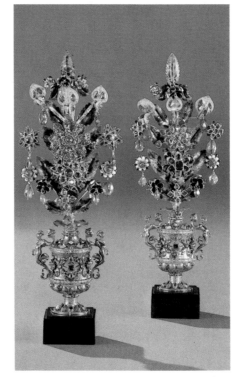

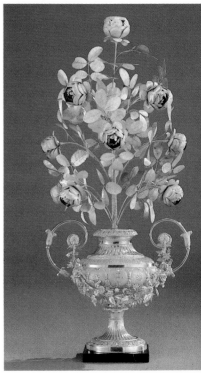

▷

TWO FLOWER VASES
Augsburg, end of 17th century
Silver-gilt, enamel, and precious stones;
H 24.3 and 25.1 cm respectively (P1 1080
and 1081)

The Burgundian inheritance and the Order of the Golden Fleece

◁

FOUR PIECES OF JEWELLERY BELONGING TO THE
EMPRESS ELISABETH
Vienna(?), before 1896
Gold, silver, diamonds, and pearls
The pieces were the personal jewellery worn
by the Empress, who was murdered in Geneva
in 1896. (XIV/193, 194, 195, 196)

With the marriage of the Duchess Maria of Burgundy to
Archduke Maximilian of Austria in 1477, the House of Haps-
burg acquired one of the richest complexes of states in Europe.
Maria's father, Charles the Bold, the last Duke of Burgundy
from the House of Valois, had been killed in the Battle of Nancy
in 1477. The lands ruled by him were partly under the French
Crown and partly belonged to the Holy Roman Empire. France
immediately collected her fiefs, which, however, did not revert
only to the Empire but also fell to Austria by way of inheritance.
This enormous increase in power—after all the Netherlands,
which were economically and culturally comparable, were part
of this inheritance—ensured the further political rise of the
dynasty, which was to be followed in the next generation by the
hereditary acquisitions of Spain and subsequently of Hungary
and Bohemia. In addition to the great territorial increase,
Maximilian and his son Philip I (the Handsome) inherited a
rich estate of jewels and works of art, although they were mere
remnants of the fabulous Burgundian treasure, which for the
most part had fallen into the hands of the victorious Swiss on
the death of Charles the Bold. Although Maximilian had to
pawn numerous objects from his holding to alleviate his
chronic lack of money, the remains of the collection still
preserved in the Treasury today give a good idea of the former
untold riches of the Dukes of Burgundy.

The Hapsburgs also inherited the Order of the Golden Fleece
at this time. It had been founded by Philip the Good of
Burgundy in 1430 on the occasion of his marriage to Isabella of
Portugal, his third wife. He had a political as well as an ethical
aim. Through the conferring of orders, the powerful elements
in the country, who constituted centrifugal forces which were
becoming increasingly dangerous, were bound more closely to
the person of the State Prince. Moreover, the knights of the
order were to defend the Christian faith, for the Turks at this
time were already beginning to threaten the Christian West,
which was the reason for Philip the Good's serious interest in
Crusades. This is clearly conveyed in the emblem of the order,
the Golden Fleece, which was adopted both from the ancient
legend of Jason and the Old Testament story of the prophet
Gideon.

The Master of the Order was the Duke, and with the
accession of Burgundy to Hapsburg, the reigning head of the
House of Austria. The number of knights was at first restricted
to 31 but was raised to 51 by the Emperor Karl V with the
consent of the Pope in 1516, and later to 60 and 70. This
demonstrates the steady growth of the Hapsburg Empire.

◁

GOLDEN ROSE
Giuseppe Spagna, Rome, 1819
Gold; *H* 60 cm
Pope Pius VI sent this rose, consecrated by
him on the Sunday before Lent, to the
Empress Carolina Augusta in 1819. (XIV/19)

EMPEROR MAXIMILIAN I (1459–1519)
Bernhard Strigel, *c* **1500**
Oil on panel; 60.5 × 41 cm (GG 922)

MARIA OF BURGUNDY (1458–82)
Nicolas Reiser(?), Schwaz, *c* **1500**
Oil on panel; 79 × 46 cm
Maria, the daughter of Duke Charles the Bold
of Burgundy, was the first wife of the Emperor
Maximilian I. As heiress of Burgundy, she
brought the House of Austria the
Netherlandish provinces. (GG 4402)

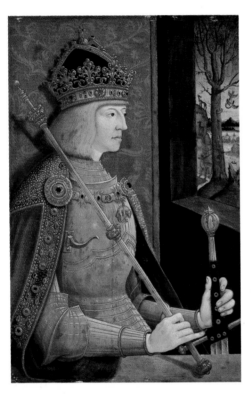

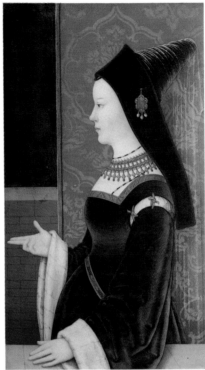

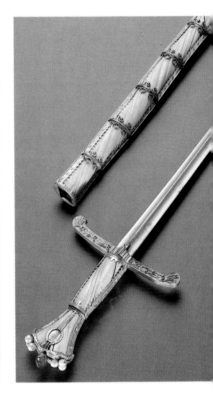

RING
Burgundian(?), second half of 15th century
Gold, set with diamonds
The diamonds form the letter 'M'.
Traditionally thought to be the engagement
ring of the Duchess Maria of Burgundy.
(P1 131)

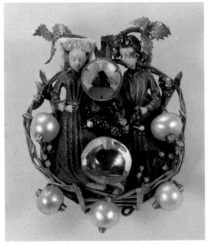

BROOCH
Netherlands, *c* **1450**
Gold, partly enamelled, precious stones, and
pearls; *Diam* approx 5 cm
The brooch depicts a betrothed couple or pair
of lovers in a garden. (P1 130)

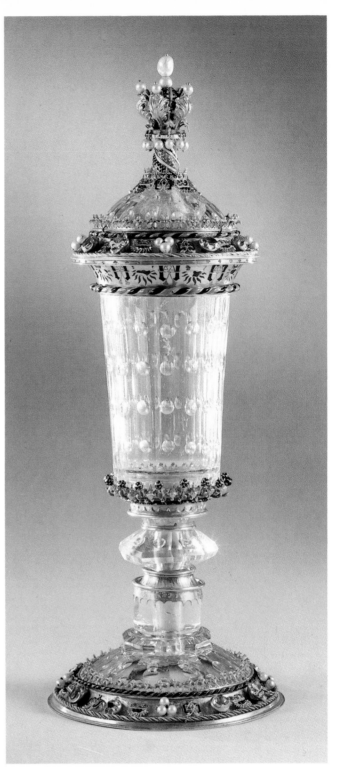

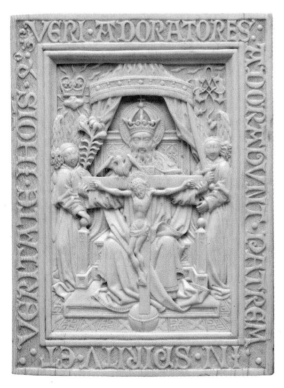

THE *AINKHÜRN* SWORD
Burgundian, second half of 15th century
Steel blade; Narwhal tusk; gold, enamel, silver
gilt, a single ruby, and pearls; 106 cm
The sword was a possession of Charles the
Bold of Burgundy and came as part of his
daughter Maria's inheritance to the Emperor
Maximilian I. (XIV/3)

GNADENSTUHL (THRONE OF GRACE)
Burgundian-Netherlandish, 1453–67
Ivory; 14.6 × 11.1 cm
According to the emblems, the relief was a
possession of Duke Philip the Good of
Burgundy. (PI 10078)

COURT GOBLET OF DUKE PHILIP THE GOOD OF
BURGUNDY
Burgundian, *c* 1453–67
Rock-crystal; gold, partly enamelled;
diamonds, rubies, and pearls; H 46 cm
The 'Court goblet' is one of the most precious
remaining pieces of the treasure of the Dukes
of Burgundy. (PI 27)

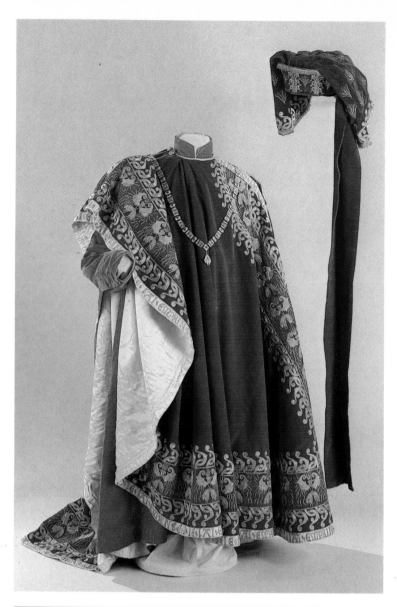

ROBES OF A KNIGHT OF THE ORDER OF THE
GOLDEN FLEECE
Vienna, second half of 18th century
Red velvet, white satin, gold embroidery
(III/TO-41)

POTENCE (ARMORIAL CHAIN) OF THE HERALD OF
THE ORDER OF THE GOLDEN FLEECE
Netherlands, after 1517
Gold, partly enamelled; *Diam* outside 143 cm,
inside 98.8 cm
The potence consists of a collar of 26 plaques;
into each of these are inserted two tiny shields
with the coat of arms of a Knight of the Order.
From the shields hangs a chain consisting of
links in the form of firestones and flints, from
which hangs a pendant Golden Fleece as the
emblem of the Order. (Dep Prot 4)

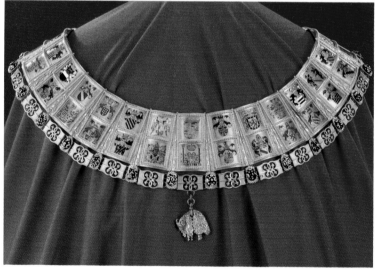

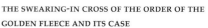

THE SWEARING-IN CROSS OF THE ORDER OF THE
GOLDEN FLEECE AND ITS CASE
**French, *c* 1400; the base of a later date
(between 1453 and 1467)**
Gold, rubies, sapphires, and pearls; *H* 36 cm
The cross originally belonged to Duke Jean of
Berry, and Philip the Good of Burgundy later
had the base altered. Newly appointed
Knights of the Order or its officials take the
oath before this cross even today.
(Dept Prot 1)

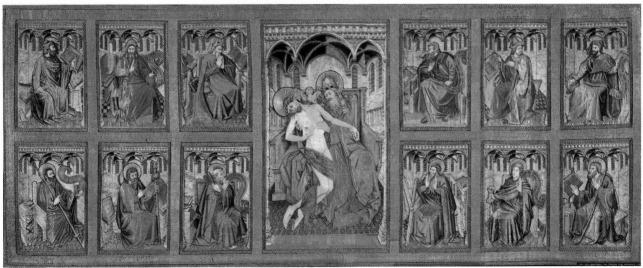

**The Vestments of the Order of the Golden
Fleece**

ALTARCLOTH (back)
**Burgundian-Netherlandish, second quarter of
15th century**
Coloured silk embroidery over gold and silver
thread; velvet, silk; pearls and pastes
330 × 129 cm (P1 18)

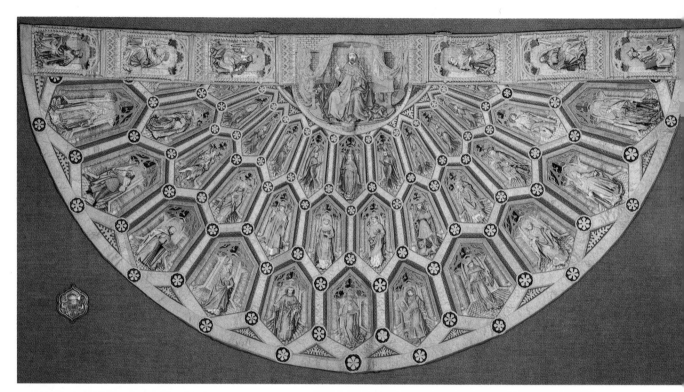

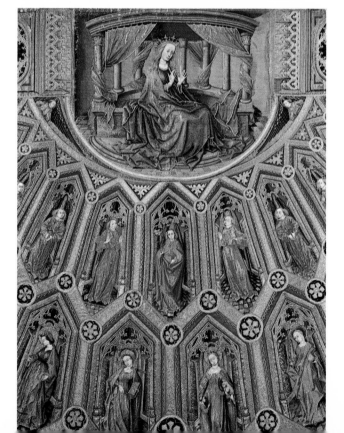

The ecclesiastical Treasury

◁
PLUVIAL (Cope of Christ)
**Burgundian-Netherlandish, second quarter of
15th century**
Coloured silk embroidery over gold and silver
threads; velvet, silk, and pearls; 164 × 330 cm
(PI 19)

◁
PLUVIAL (Cope of Mary; detail)
**Burgundian-Netherlandish, second quarter of
15th century**
Coloured silk embroidery over gold and silver
thread; velvet, silk, and pearls; 164 × 330 cm
The master who designed the pluvials is as yet
unidentified. Stylistically he is close to Rogier
van der Weyden. (PI 21)

◁ ◁
CLASP FOR PLUVIAL
**Burgundian-Netherlandish, *c* 1500 with later
additions**
Silver, parcel-gilt and enamelled; *H* 19 cm
The coat of arms is that of Philip the
Handsome, son of Emperor Maximilian I and
Maria of Burgundy. (Dep Prot 31)

The religious Treasury contains mainly liturgical accessories:
paraments and relics which were in use in the various Court
churches and chapels in Vienna, Schönbrunn, Laxenburg, and
Baden and to some extent still are. The main holdings to be
mentioned here are those of the Hofburg chapel in Vienna; this
is because Emperor Joseph II, on his accession to power in
1780, had placed the religious Treasury under the adminis-
tration of the Court Chaplain, and had thus created a climate
for the merging of holdings of the most varied provenance. As
the Hofburg Chaplain had episcopal rank and as the most
important Church ceremonies took place in the Hofburg
chapel, the decoration of this church was extremely rich. Its
stock of paraments, stemming mainly from the Baroque period,
merits special attention.

Apart from these, it is the numerous relics in their extremely
sumptuous cases that attract the attention of the visitor. They
derive mainly from the early seventeenth century, the time of
the Counter Reformation. These reliquaries were for the most
part made in the Imperial Court Workshop founded by Em-
peror Rudolf II or in south German workshops. They are a
testimony to the great piety of the Hapsburgs and also to the
ostentatious splendour expressed in their religious monu-
ments; but they testify also to the Wittelsbachs, who were
related to the Hapsburgs by marriage, and who were bearers
and champions of Catholicism within the Holy Roman Empire,
which was gaining strength. Parts of this stock of relics, which
had originally served the private worship of its owners, had
later found their way into the treasure of the *Kapuzinerkirche*
(Capuchin church) in Vienna, which had been the burial church
of the Hapsburgs since 1619. They were transferred back into
the care of the ecclesiastical Treasury.

Here we are dealing largely with objects which served at one
and the same time both as vehicles of worship and as a pledge
of a better after-life. The keys to the Hapsburg coffins, kept safe
in the ecclesiastical Treasury, also represent a link with the
other world, since they are a symbol of the end of earthly
existence and the beginning of the hoped for eternal life. Thus
the ecclesiastical Treasury is an outstanding monument to the
deep religious feeling of the Austrian nation.

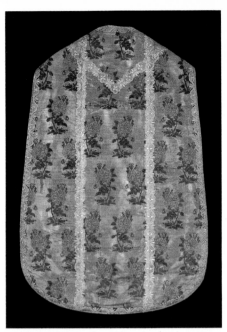

△

THREE CHASUBLES
Austrian, 17th–18th century
Brocade or gold embroidery on silk (A 610, 115
and 22)

CHASUBLE WITH CHRIST ON THE TREE CROSS
Bohemian or Austrian, *c* 1500
Relief embroidery on red velvet, with later
additions. (A 11)

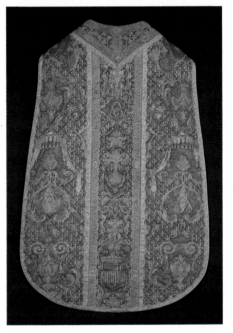

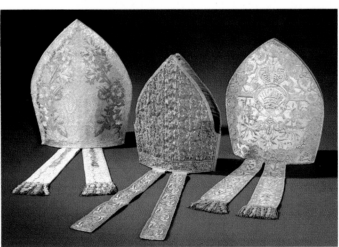

△

THREE MITRES
German and Austrian, 16th–18th century
Silk brocade with silk; gold and silver
embroidery
As the Court chaplain was always of Bishop's
rank, he had the right to wear a mitre. (A 28,
Kap 4 and A2)

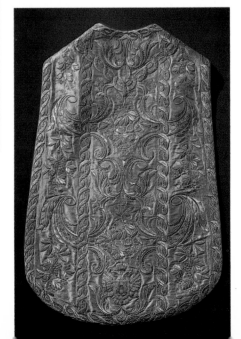

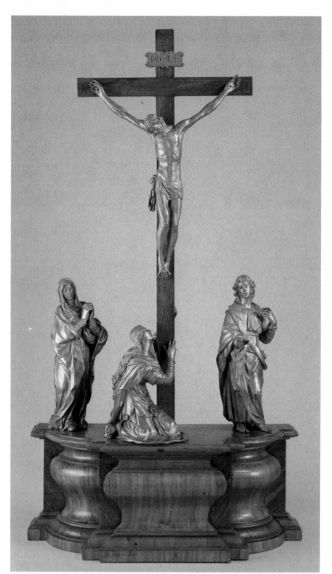

CRUCIFIXION GROUP
South German, early 17th century; figure of Christ after Giambologna
Bronze, light brown patina;
Crucifix *H* 101.5 cm (E 34)

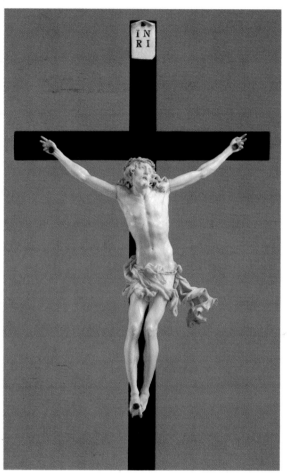

CRUCIFIX
Austrian, *c* 1710–20
Ivory on black polished wood; almandine;
H overall 87.5 cm (46)

◁

MEISSEN ALTAR SET
Johann Joachim Kaendler, *c* 1737–41
Porcelain
This set was a present from Augustus III of Saxony to his mother-in-law, the Dowager Empress Amalia. (P1 7078-7111)

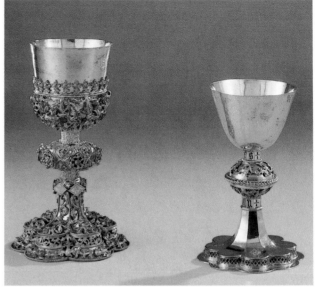

▷

TWO CHALICES
Right: **South German, 1438**
Silver, parcel-gilt, *H* 19 cm
On the base are the letters AEIOV (the mark
identifying it as belonging to the Emperor
Friedrich III) and the year 1438.
Left: **South-east German, *c* 1500**
Silver, parcel-gilt; *H* 23.3 cm (B1 and B10)

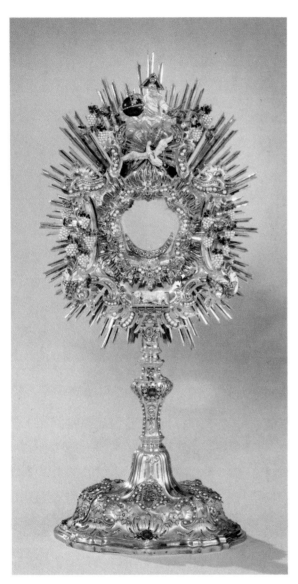

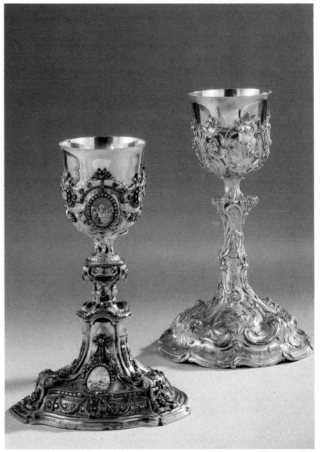

MONSTRANCE
Vienna, 1760
Silver-gilt, and enamel; diamonds, emeralds,
sapphires, jacinths, and pearls; *H* 71.5 cm
(B 30)

TWO CHALICES
Right: **J. Hueber, Vienna, 1767**
Silver-gilt; *H* 30 cm
Left: **Josef Moser, Vienna, 1775**
Silver-gilt and enamel; diamonds, rubies,
emeralds, amethysts, and garnets; *H* 27.2 cm
(B4 and B8)

PENDANT OF CHARLEMAGNE

German, 14th century(?), possibly a re-fashioned Carolingian reliquary

Gold on a wooden core, semi-precious stones, and a single onyx cameo dating from the 1st–2nd century; *H* 14.5 cm

The relic is said to have been worn as a talisman by Charlemagne. (D 128)

▽

RELIQUARY MONSTRANCE

Venetian, 14th century with 16th century German additions

Silver and silver gilt; precious and semi-precious stones, rock-crystal, corals, and pearls; miniatures on vellum; *H* 68.5 cm

(Kap 56)

▽ ▽

MARSUPIUM (POUCH) OF KING STEPHAN OF HUNGARY

Slavonic, 12th–13th century

Silk with silk and gold embroidery; partly painted; silver-gilt; garnets and pearls; *H* 18 cm

Tradition has it that this was a small pouch used by King Stephan as a portable reliquary. (Kap 186)

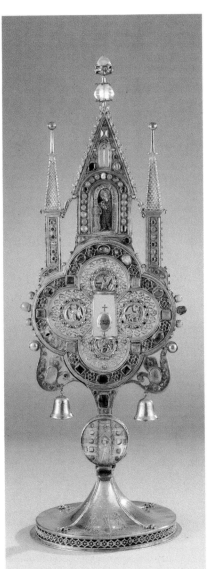

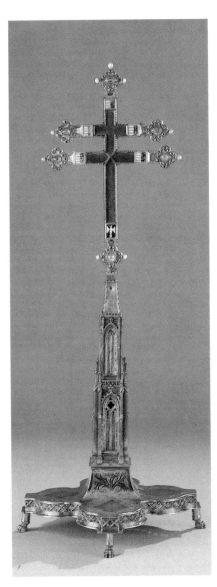

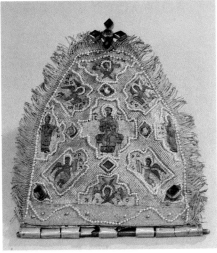

RELIQUARY CROSS OF KING LUDWIG THE GREAT OF HUNGARY

Hungarian(?) between 1370 and 1382

Gold, silver-gilt, and enamel; rubies, sapphires, emeralds, pearls, and glass; *H* overall 67.2 cm (D 251, 252)

TWO RELIQUARIES WITH THE WAX BUSTS OF
ST VALERIANUS AND ST TIBURTIUS
**After designs by Hans Krumper, Munich,
beginning of 17th century**
Ebony; wax; cloth; gold enamel, gilt bronze;
H 36 m (D 70 and 71)

OSTENSORY CONTAINING VARIOUS RELICS
OF CHRIST
South German, beginning of 17th century
Ebony; gold and enamel; rock-crystal,
diamonds, rubies, and pearls; H 48.5 cm
(D 23)

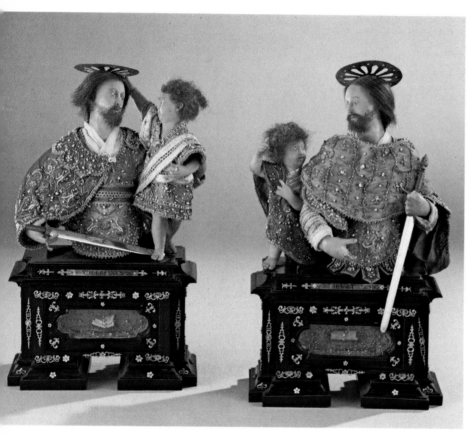

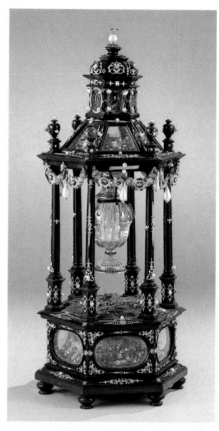

PRAYER-BOOK OF EMPEROR FERDINAND II
South German, 1590
Gold covers, enamelled; 6 × 4.8 cm;
pages vellum, gilt-edged; 5.6 × 4.4 cm
Ferdinand was given this prayerbook by his
parents in 1590 on leaving for Ingolstadt
University. (D 27)

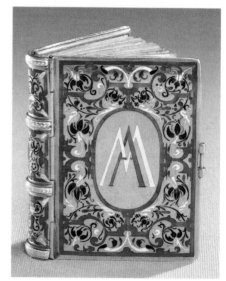

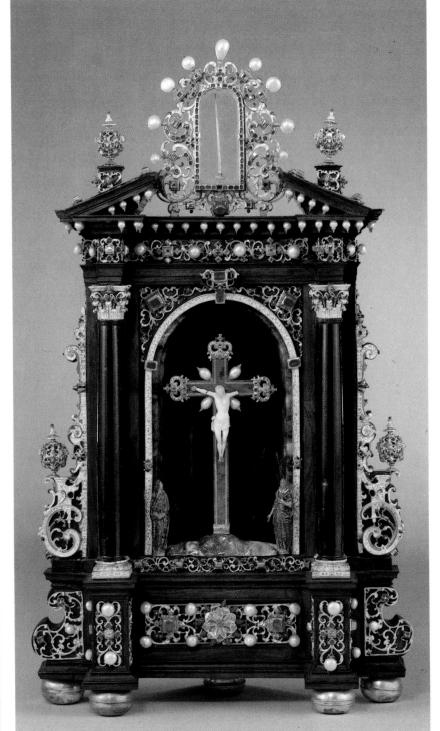

TWO SMALL HOUSE ALTARS
Ottavio Miseroni, who worked at the Imperial Court Workshop in Prague after 1588
Jasper, agate, lapis lazuli, diamonds, rubies, and pearls; gold, enamel, silver-gilt; *H* 30.5 and 33 cm
One of the *commessi* in the medallions depicts Mary with the Child, the other St Anne. (Kap 219 and 220)

SMALL HOUSE ALTAR WITH CRUCIFIXION GROUP
Prague, Imperial Court Workshop, early 17th century
Ebony; jasper, jasper agate, agate, gold, enamel, table-cut diamond, rubies, and pearls; *H* 44.2 cm
In the pediment is a thorn from the Crown of Christ. These small house altars with relics, which are precious both artistically and in their materials, are characteristic of the Prague Court Workshops, founded before the reign of the Emperor Rudolf II. (Kap 221)

OSTENSORY CONTAINING A THORN FROM THE
CROWN OF CHRIST AND RELICS OF VARIOUS SAINTS
South German, Augsburg(?), 1592
Ebony; rock-crystal; gold and enamel;
diamonds, rubies, emeralds, and pearls;
H 50.4 cm
The ostensory is surmounted by an allegorical
figure of Faith. It is decorated with what is
presumed to be an unknown lady's jewellery.
(D 21)

OSTENSORY CONTAINING RELICS OF VARIOUS
SAINTS
Matthäus Wallbaum, Augsburg, 1588
Ebony, silver, parcel-gilt; H 49.8 cm (D 89)

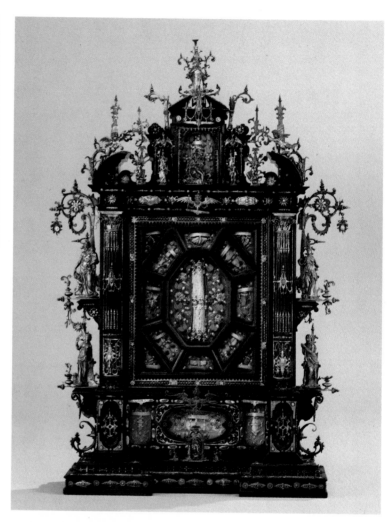

▷
TWO SMALL HOUSE ALTARS AND AN OSTENSORY
**Matthäus Wallbaum and workshop,
Augsburg, 1588**
Ebony; silver, parcel-gilt; miniatures;
H 40.7, 36.4 and 46.8 cm (D 179, 173, 90)

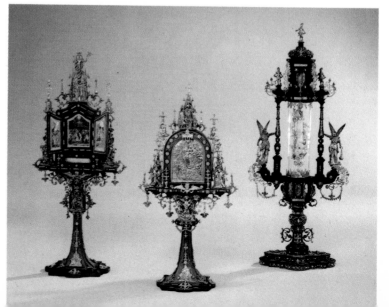

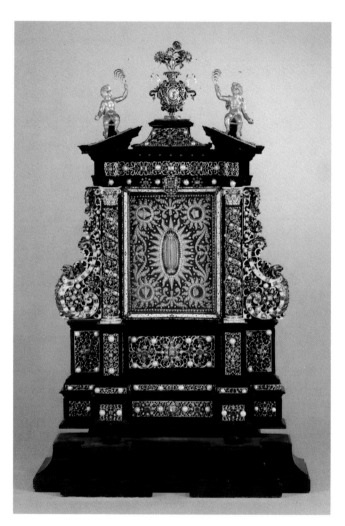

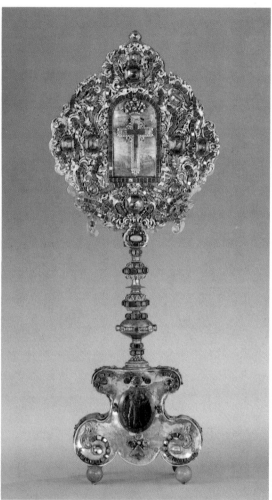

SMALL HOUSE ALTAR WITH A THORN FROM THE
CROWN OF CHRIST
South German, mid 17th century
Ebony; gold, enamel, silver, parcel-gilt and
enamel; gilt-bronze; chrysolite, almandine,
rock crystal, garnets, and pearls; H 70 cm
(D 59)

RELIQUARY CONTAINING A FRAGMENT OF THE
HOLY CROSS
Vienna(?), 1668
Gold, silver-gilt and enamel; diamonds,
chrysoprases, garnets, amethysts, agate,
carnelians, and rock-crystal; H 53.5 cm
This particle of the Cross, which belonged to
the Dowager Empress Eleonora Gonzaga,
miraculously survived the Hofburg (Imperial
Palace) fire in 1669. This prompted the
foundation of the 'Sternkreuz Orden' (Order
of the Starry Cross), the highest Ladies' order
of the House of Austria. (D 25)

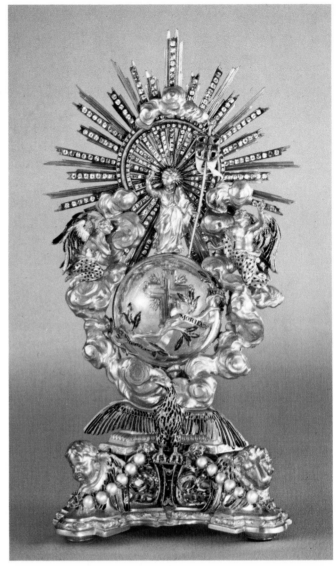

▷

PACIFICALE (RELIQUARY)

Johann Baptist Känischbauer von Hohenried, Vienna, 1726

Gold and enamel, silver; diamonds, rubies, rock-crystal, pearls, and glass; *H* 25.3 cm
It is possible that the design of this *pacificale*, glorifying the Cross, is based on a drawing by Johann Bernhard Fischer von Erlach.

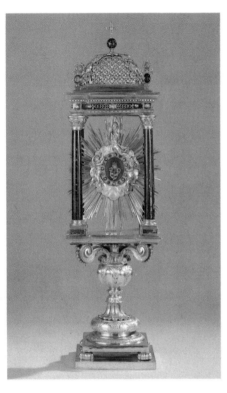

△

OSTENSORY CONTAINING A TOOTH OF ST PETER

Rome, probably 1853

Parcel-gilt silver; bronze; lapis lazuli, diamonds, rubies, emeralds, sapphires, topazes, aquamarines, amethysts, and jacinths; *H* 78.5 cm
The ostensory was a present from Pope Pius IX to the Emperor Franz Josef I on his lucky escape from an attempt on his life. (D 45)

▷

OSTENSORY WITH A NAIL FROM THE CROSS OF CHRIST

Vienna(?), mid 17th century

Gold and enamel; silver-gilt; emeralds, sapphires, topazes, amethysts, aquamarine, jacinth, turquoises, and garnets; *H* 79.6 cm
(D 62)

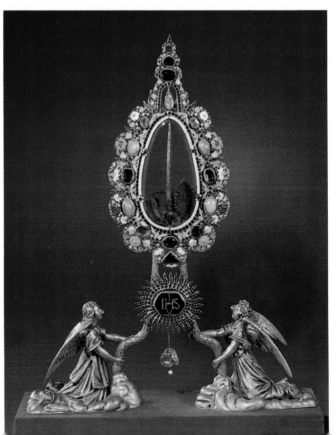

SUDARIUM OF ST VERONICA
Italian, *c* 1617 and Austrian, *c* 1800
Linen; ebony; parcel-gilt silver; gilt copper;
mother-of-pearl; onyx cameos; ivory;
58.5 × 48.4 cm
The Sudarium came from Rome. The Princess
Savelli presented it to Karl VI in 1720. Since
there are several relics of this kind, their
existence is thought to be attributable to the
folding, and consequent falling apart, of the
cloth into several parts. (D 108)

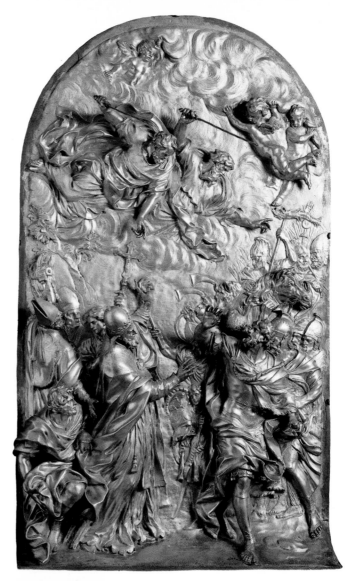

△
MEETING BETWEEN POPE LEO THE GREAT AND
ATTILA, KING OF THE HUNS
Alessandro Algardi, Rome, *c* 1650
Gilt-bronze; *H* 98 cm
Cast of the model made for the massive marble
relief in St Peter's, Rome. (D 164)

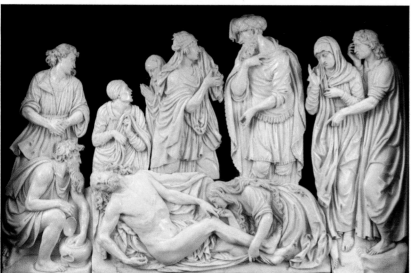

THE LAMENTATION OF CHRIST
**Leonhard Kern, Schwäbisch Hall, first half of
17th century**
Ivory relief in a contemporary brown wooden
casket under glass. 24.5 × 40.2 cm (D 198)

CABINET HOLDING THE KEYS TO THE COFFINS OF
THE HAPSBURGS
**Alexander Albert, Court cabinet maker,
Vienna, 1895**
The drawers in the middle section are reserved
for the keys to the coffins of the Emperors and
their closest families, while the keys to the
coffins of all other Archdukes of the House of
Austria are kept in the side sections.
Altogether the keys to 139 coffins are kept in
the cabinet, the oldest of these dating back to
the seventeenth century. (XVI A 24)

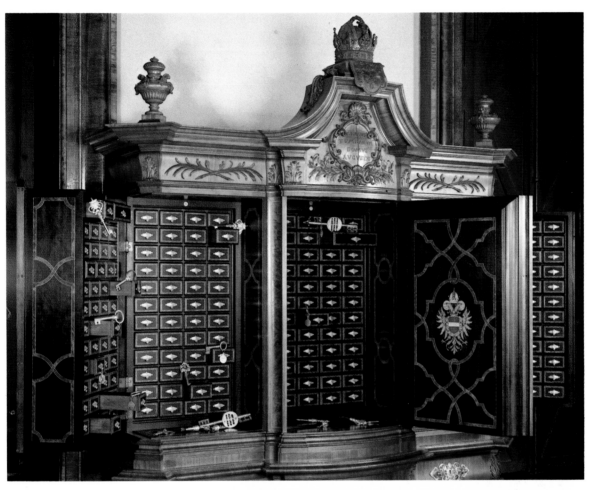

▷

ALLEGORY ON THE DEATH OF THE EMPEROR
FERDINAND (11 March 1657)
Daniel Neuberger, 1657
Wax; glittering coloured quartz sand; in an
ebony casket under glass; 36.5 × 46.5 cm
(Kap 244)

The Collection of sculpture and decorative arts
Rudolf Distelberger

Introduction

The title 'Collection of sculpture and decorative arts' has only existed since 1919, when it succeeded the even more unhappy 'Collection of industrial arts'. Both descriptions rely upon a narrow definition of the concept of 'decorative arts' (*Kunstgewerbe*), which originated in the nineteenth century and is still in use today. *Kunstgewerbe* here describes a genre of objects which were not fashioned for their own sake, but were aesthetically created as utility objects.

The name of the Collection is thus misleading, inasmuch as it does not contain a significant amount of the usual large sculpture, and as the modern definition of *Kunstgewerbe* does not adequately define those objects which have been preserved in it. The explanation of this confusion is to be found in the particular kind of objects which were collected in the sixteenth and seventeenth centuries, and the point of view from which these objects were expected to be seen. The Collection contains, with the exception of objects from the Middle Ages and a few isolated historical souvenir pieces, hardly any objects which entered the Museum because they had fallen out of use. In most cases, they had, in fact, been made specially for the Collection, that is to say for the various Hapsburg *Kunstkammer* (art rooms) which were its forerunners; or had alternatively been made for general acceptance in a princely art room. Whole artistic genres here included, such as small bronzes, statuettes, and turners' work in ivory, or gem-carving, owe their existence and flourishing development to the high standards demanded by the princes for their *Kunstkammer*.

In the sixteenth century, the *Kunstkammer*, whose collecting history goes back as far as the fourteenth century, had developed into an encyclopedic collection embracing specimens from the various fields of nature (*Naturalia*), of art and craft (*Artefacta*), and of science (*Scientifica*). The various fields might overlap in a single object, when, for example, a rare natural product was sumptuously mounted and artistically fashioned. However, the interest of a princely collector in a natural object was not determined by scientific criteria in the modern sense; on the contrary, such an object was acquired on account of its rarity value or its exceptional and exotic quality, or because magic powers of healing and miracle-working were ascribed to it. In the case of an artifact, artistic quality, the ingenuity or virtuosity of the work, its antiquity, its costliness, or even dynastic or historical factors were significant to its collectability.

The phenomenon of the *Kunstkammer* should be seen in the context of the élitist social position of a prince and his consequent claim to universal dominion over the whole of creation. His efforts culminated in the production of a microcosm which became a mirror or model of the universe and allowed him personally to appear in an ideologically heightened light. Like God above the universe, so stood the prince, who derived his claims to power from the grace of God, above his world, which he appropriated in the objects of the *Kunstkammer*. In accordance with his rank in society, he tried to assemble around him the noblest, rarest, or most remarkable products of nature and also the most admirable and precious creations of human artistic ability. In addition, the exotic objects illustrated the global scope of his will and influence. The pretensions of the Emperor rose even higher than those of other princes, which accounts for the extremely high quality of the items in the Vienna Collection. The Emperor Rudolf II even had the Augsburg clockmaker and contractor Georg Roll incarcerated because he believed that he had furnished him with a celestial globe inferior to that supplied to his brother, the Archduke Ernst.

The usability or usefulness of the objects was generally of no importance, except in the case of the *Scientifica*—watches, clock-work figurines, and instruments—in which the manifold workings and functions of their mechanisms were, of course, the real object of admiration. What emerged from the *Kunstkammer* were rather the first non-utilitarian works of art, that is to say those that were completely devoid of any non-aesthetic significance. Even objects which had the appearance of being able to fulfil a useful purpose were not utility objects. Christoph Jamnitzer's ewer and dish (p 108) might be quoted as examples, for they are absolutely unusable, and the lid of the ewer cannot be opened. We are presented here with merely the representation of a ewer and dish, not by means of brush or pen but in gilded silver. Similarly, the vessels made of precious stones, ostrich eggs, exotic nuts, rhinoceros horn, or the delicate ivory goblets turned on the lathe, are mere representations of vessels for the *Kunstkammer*, which, apart from their rare natural materials, were particularly valued for the masterly conquest of the technical difficulties in the working of the particular substance. The famous *saliera* (salt-cellar) of Cellini is primarily a work of art, then a splendid table decoration, and only finally a usable salt-cellar. The utilitarian purpose is secondary to the artistic one, and only determines the form as a representational theme. The so-called *Kunstkammer* pieces thus do not fall under the modern headings of 'decorative' or 'applied' arts but are non-utilitarian display objects of the highest artistic and material standard. They form an artistic genre which embraces all decorative art techniques, and whose themes are drawn both from figure motives and also frequently from the world of objects actually used by a prince. Questions as to their function are pointless if they are directed to their practical application and not to their significance in the prince's conception of the world and of himself.

The Collection of sculpture and decorative arts contains a combination of treasures from several Hapsburg *Kunstkammer*. Among these collections two are worthy of special mention, since the nucleus of the present Collection is derived from

them. The first is the *Kunstkammer* and Treasury of Archduke Ferdinand II (1529–95), which is also known by the title of the Ambras Collection, since it was first exhibited in Ambras Castle near Innsbruck. It also supplied the majority of the pieces still preserved from the older collections of Emperor Friedrich III (1415–93), Maximilian I (1459–1519), and Ferdinand I (1503–64). Secondly, the *Kunstkammer* of Emperor Rudolf II (1552–1612), which had been compiled in Prague and to which had been transferred Rudolf's share of the inheritance from the collection of his father, Maximilian II (1527–76), is significant. Although many of Rudolf's treasures were permanently lost to the hereditary collection after the plundering of the Prague Castle by General Königsmark in the last days of the Thirty Years' War, he was nevertheless enriched by those objects which Emperor Matthias and Ferdinand II had previously brought to Vienna. They included the most outstanding works of goldsmiths' and gem-carvers' art of the time around 1600, as well as some masterly bronzes.

In the seventeenth century objects were added from the art collections of Archduke Leopold Wilhelm (1614–62), the younger son of Emperor Ferdinand II, who was the Governor of the Netherlands. Although he is doubtless mainly renowned as one of the fathers of the Paintings Gallery, he had also bought, along with the great painting collections from Italy, excellent Renaissance bronzes and also collected small sculpture in stone and wood.

The Vienna Treasury was in fact originally the oldest Hapsburg *Kunstkammer*. Apart from the transfer of the treasures from Prague, it was continuously enriched during the reigns of the Emperors Ferdinand II (1619–1637), Ferdinand III (1637–57), and Leopold I (1658–1705). The popularity of ivory statuettes and reliefs in the seventeenth century pushed the small bronzes into the background. Alongside works in semi-precious stones which continued to be very popular at the Viennese Court, turned pieces in ivory, carvings in rhinoceros horn, and miniature wax models were coming into fashion.

In the eighteenth century there was no longer any *Kunstkammer* collecting activity worth mentioning. The name 'treasury' remained, and it was re-organized under Maria Theresa. The remains of the *Graz Kunstkammer*, founded by Archduke Karl II (1540–90) on the nucleus of his father Maximilian II's estate, was incorporated into it.

The main addition in the nineteenth century was the transfer of the Ambras Collection to Vienna in 1806. It was established in 1814 in the former Garden Palace of Prince Eugene of Savoy, the Lower Belvedere. The combination of these objects with the pieces of the Vienna Treasury only took place in 1890/1 in the course of the re-organization of all the Hapsburg artistic possessions when they were removed to the newly erected Art Historical Museum. Between 1870 and 1880 a series of objects had already been transferred from the Collection of antiquities and from the Emperor's Castle of Laxenburg.

The twentieth century has recently but unexpectedly considerably enlarged the Collection. The first addition was the so-called 'Este Collection', which had been in the possession of the Obizzi family. The family's main collector was the Marquis Tomaso degli Obizzi, who died in 1805, although the Collection's origins go back to the seventeenth century. By way of inheritance it had found its way into the hands of the Austrian line of Este, and the successor to the throne, Archduke Franz Ferdinand, whose assassination was the catalyst of the First World War, had it brought to Vienna. At first it was displayed as a unit on its own and only in 1935 was it divided up among the collections of the Art Historical Museum. It contains among other works Italian sculpture of the Middle Ages and the Renaissance as well as bronzes and plaques.

The Museum's tapestry collection came originally from the Imperial Estate, and in 1921 was placed under the administration of the Collection. Owing to the fact that the tapestries were and are hung for only short periods of time, they have retained their splendid colours, and it is probably true to say that they constitute the best preserved collection of this kind in the world.

The twentieth century has also seen a number of valuable bequests. Gustav von Benda left his precious collection to the Museum in 1932. It contains many and varied important pieces, but what was of greatest value for the Collection of sculpture and decorative arts were the works of the early Florentine Renaissance. Clarisse de Rothschild dedicated a set of clocks and scientific instruments to the Collection in 1949 in memory of Dr Alphonse de Rothschild. Smaller additions resulted from exchanges with other public museums in Vienna, but at the same time they occasioned considerable losses. There were a few successful isolated purchases of significance.

The wide ramifications of the genealogy of the Collection of sculpture and decorative arts can also be seen in the indications of provenance in the inscriptions of the exhibits, where the inventories in which the pieces were first mentioned are often

quoted. The objects are not always identifiable in the oldest possible inventory, with the result that only a general indication of origin is possible, as for example 'from the Treasury' or 'from the Ambras Collection'. A part of this time-consuming task of establishing the sequence of the inventories in respect of all the pieces has not yet been completed. The inventories of the Vienna Treasury have been lost and may well have been destroyed at the time of its re-arrangement in 1750. Since nearly all the important inventories are published and since constant reference is made to them, it is appropriate to quote them here with their place of origin, in chronological order:

Inventory of the estate of Archduke Ferdinand of Tirol in Ruhelust, Innsbruck, and Ambras, dating from 30 May 1596 (abbreviated to: Inventory of the Ambras Collection of 1596); in *Year book of the art history collections of A. H. Kaiserhaus* (the Supreme Imperial House), Vol VII/2, 1888, PP CCXXVI-CCCXII and Vol X, 1889, pp I-x (Library).

The *Kunstkammer* inventory of Emperor Rudolf II, 1607–11; in *Year book of the art history collections in Vienna*, Vol 72, 1976.

Inventory of Emperor Matthias's estate (after 5 May 1619); in *Year book of the art history collections of the A. H. Kaiserhaus*, Vol XX/2, 1899, PP XLIX-CXXII (also contains Emperor Rudolf II's art possessions, which do not appear in the inventory of 1607–11).

Inventory of Archduke Leopold Wilhelm's art collections; dating from 14 July 1659; in *Yearbook of the art history collections of the A. H. Kaiserhaus*, Vol I/2, 1883, pp LXXIX-CLXXVII.

Inventory of the Imperial secular Treasury in Vienna, 1750; in *Yearbook of the art history collections of the A. H. Kaiserhaus*, Vol X/2, 1889, pp CCLII-CCCXXIV.

Ernst Ritter von Birk, inventory of all the Dutch tapestries and Gobelins to be found in the possession of the A. H. Kaiserhaus; in *Yearbook of the art history collections of the A. H. Kaiserhaus*, Vol I/1, 1883, pp 213–248, Vol II/1, 1884, pp 167–216.

The Este Art Collection, as relevant to the Collection of sculpture and decorative arts is published: Leo Planiscig, *The Este Art Collection*, Vol I, *Skulpturen und Plastiken des Mittelalters und der Renaissance* (Medieval and Renaissance Sculpture) Vienna, 1919.

The Middle Ages

The art of the Middle Ages served almost exclusively religious and sacred purposes. The more extensively religious demands determined life and thought, the more strictly and solemnly were they set to work in art. The connection with antiquity was preserved for understandable reasons, for indeed both Emperor and Church in Byzantium felt themselves to be the direct successors of the old Empire with Constantinople, the 'new Rome' as its centre, while in ancient Rome the Church re-interpreted the old idea of Rome's supremacy in a Christian context and never gave up its claim to leadership. The old Imperial notions were revived in the secular power of Charlemagne. The great importance of the rôle played by ancient tradition can be seen in three ivory reliefs from the ninth and tenth centuries from both West and East (p 53). The use in worship of the Aquamanile, one of the finest sprinkling vessels in the Collection, is revealed in the symbolic shape of the griffin. It is a symbol of Christ, who purifies the soul just as the vessel purifies the hands with water. A masterpiece of late Romanesque goldsmiths' art is the Wilten chalice (p 55), whose iconographic sequence traces the history of human salvation from the Creation to the Redemption. The Bishop of Pecs presented it to the Council of Trent in 1562 as a proof that in former times Communion was administered to the faithful in two forms.

Worldly ends were served by the remarkable *Püsterich* (fire-blower) (p 54). The object was filled with water and placed in the embers of a fire, whereupon it emitted steam from small holes in the nose and mouth and thus fanned the flames. Among the most important Medieval objects in the Vienna Collection is the large group of masterpieces of gem-carving. The great rock-crystal ewer (p 56), for example, with its many facets and double handle has no match anywhere in the world. The provenance and dating of these marvellous pieces, as well as their original use, have not yet been clarified, but they could be connected with the revival of the ancient art of gem-carving at the time of the conquest of Constantinople in 1204, when not only ancient cameos but probably also lapidaries had been brought to the west. The slightly smaller, extremely finely-cut ewer (p 56) with its elegantly curved outline, in the clearest crystal, can only be a product of French Court art of the fourteenth century. The accentuation of the Imperial idea and the deliberate propagandist identification of himself with Augustus by the Hohenstaufen Friederich II (reigned 1212–50) accounts for the imitation of Antiquity in gem-carving at his Court in Southern Italy, several outstanding examples of which are in the collection (p 57). No princely collection could now be without the precious stones that were worked into vessels or gems.

Around 1400 the soft, curvilinear forms of the International Gothic style were widespread throughout Europe. One of the most significant creations of German sculpture at this time is the courtly, refined 'Krumau Madonna' (p 59), whose soft, flowing cascades of folds form under her knees into a supporting triangle. This style is also exemplified in the Venetian bust (p 59) with its portrait-like features, and the greater part of the Vienna pattern book (*Musterbuch*) (p 60). The two Ambras sets of playing cards (pp 60, 61), however—the Court hunt set with wonderful natural scenes—already belong to the middle of the last phase of the late Gothic period, which leads up to works such as the Thalheim Madonna (p 63) and the standing Madonna of Tilman Riemenschneider (p 64), which represent an ideal type of middle-class woman.

The high secular Court culture and art of the late Middle Ages are represented, along with the Ambras playing cards, by the richly ornamented Venetian games board and the French ivory casket of the fourteenth century (both p 58). Jewel-boxes from the Embriachi workshop (p 58), several of which are in the Collection, and the artistically carved Troubadour's box in wood with the *Wildleute* (personifications of natural forces) (p 63) are also representative. The Adder's Tongue Credence (p 61), which probably came from the Emperor Maximilian I bequest, is an extremely rare piece, as only two other such pieces have been preserved. Early display pieces, which might have been in the possession of Emperor Friederich III, are the Burgundian State goblet (p 61) and a goblet with cover in rock crystal (p 62), both of which bear Friederich's mark, as well as the double goblets of rock crystal or veined wood (pp 62, 64), which may rank as early *Kunstkammer* pieces.

ST GREGORY WITH THE SCRIBES
Carolingian, Franco-Saxon school, late 9th century
Ivory; 20.5 × 12.5 cm
Originally the centre section of the cover of a tabernacle. Acquired in 1928 from the Heiligenkreuz Monastery; 1647, in the collection of Archduke Leopold Wilhelm. (8399)

△
ASCENSION OF CHRIST
Metz, c 980
Ivory; 20.6 × 14.4 cm
Formerly the centre section of a book cover.
Acquired in 1915 from a private owner.
(7284)

◁
SS PETER AND ANDREW
Constantinople, middle of 10th century (before 959)
Ivory; 24.6 × 13.5 cm
Greek inscription: 'Brothers in the flesh, prophets of the divine mystery, obtain for the ruler Constantine forgiveness of his sins.'
Reference to Constantine VII *Porphyrogenetos* (912–959)
From the Antiquities Room (in the collection of Gabriel Riccardi, Florence during the 18th century). (8136)

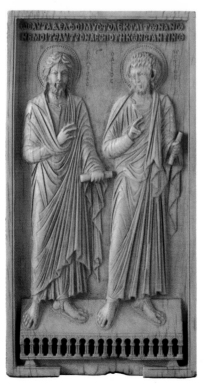

53

PÜSTERICH (FIRE-BLOWER, AEOLOPILE)
North Italian(?), 12th century
Bronze cast; H 23.5 cm
From the Antiquities Room. (5702)

AQUAMANILE (WATER JUG) IN THE FORM OF A
GRIFFIN
Lotharingian, 2nd half of 12th century
Gilt bronze, part-silvered, niello; H 17 cm
Served for liturgical hand-washing.
From the Antiquities Room. (83)

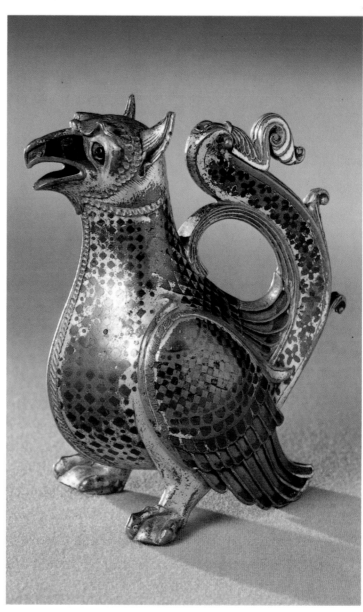

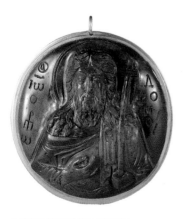

CAMEO: JOHN THE BAPTIST
Constantinople, 11th–12th century
Heliotrope; gold mounts; Diam 4.6 cm
Listed in the Treasury inventory of 1750.
(IXa 20)

▷

COMMUNION CHALICE FROM ST PETER'S ABBEY
SALZBURG
Salzburg, c 1160–80
Silver-gilt, the knop beryl, jewelled mount;
H 23 cm
On the base and bowl are twelve figures
of the Old Testament (identification still
incomplete).
Acquired 1952 from the collection of Oskar
Bondy, Vienna. (9983)

THE WILTEN CHALICE WITH PATEN AND *FISTULAE*
(Eucharistic reeds)
Lower Saxon, *c* 1180
Silver, parcel-gilt, niello; *H* 16.7 cm,
Diam of paten 23.5 cm, *fistulae L* 19.6 cm each
On the chalice and paten are pictures from the
Scriptures: on the base scenes from the Old
Testament, on the bowl from the New
Testament. The paten shows the Death and
Resurrection of Christ and the associated
events. Count Berthold III of Andechs
(1148–88), who is mentioned in the
inscription, was instrumental in bringing the
chalice to the Abbey of Wilten. Acquired in
1938 from Wilten Abbey, Innsbruck. (8924)

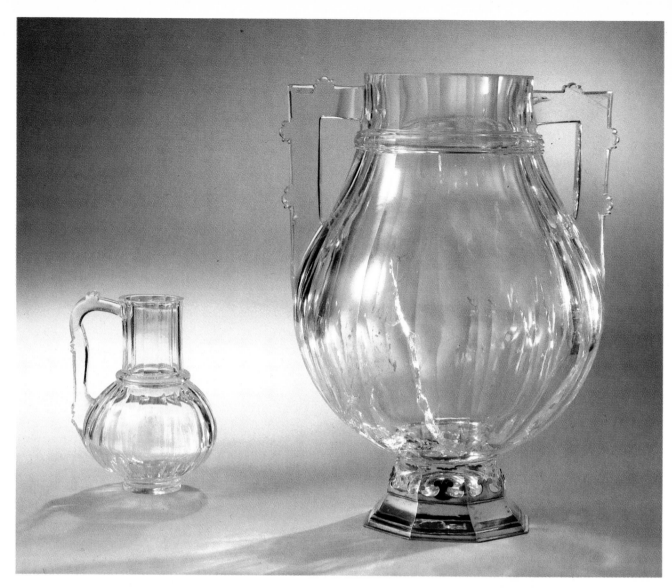

ROCK-CRYSTAL EWERS
**Origin uncertain (South Italy?, Venice?),
13th century**
H 41.3 cm and 19 cm
The two-handled bowl is the largest rock-
crystal vessel surviving from the Middle Ages.
Its former use is uncertain.
Listed in the Treasury inventory of 1750.
(2316, 1513)

▷
ROCK-CRYSTAL EWER
Paris(?), 14th century?
H 26.1 cm
From the Treasury. (2272)

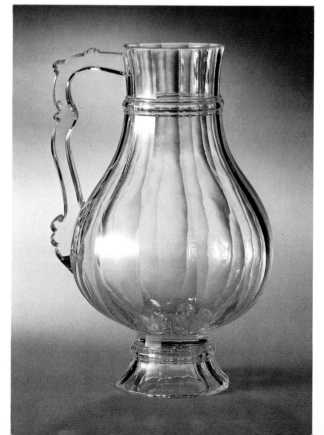

AGATE BOWL

Prague(?) 2nd half of 14th century

Mount silver gilt; *H* 18.6 cm, *Diam* 27.2 cm
Probably a product of the Prague Court
workshop of Emperor Karl IV. From the
Ambras Collection. (6699)

CAMEO: POSEIDON AS PATRON OF THE ISTHMIAN GAMES

Italian, Hohenstaufen, 1st half of 13th century

Onyx; gold mount early 19th-century; *H* 7 cm,
W 8.8 cm
Listed in the Estate inventory of Emperor
Matthias of 1619. (IXa62)

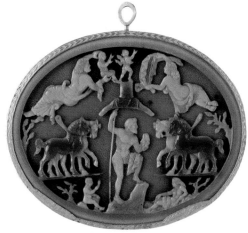

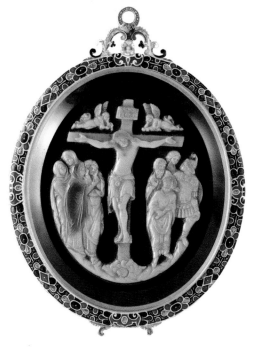

△

CAMEO: THE CRUCIFIXION OF CHRIST

Italian, 2nd half of 13th century

Onyx; mount French, 2nd half of 16th century;
gold and enamel; *H* 9.2 cm, *W* 6.7 cm
Listed in the Treasury inventory of 1750.
(IXa4)

◁

AMETHYST BOWL

Venice, late 14th/early 5th century

Mount silver-gilt; *H* 16.3 cm, *L* 23.8 cm
Listed in Treasury inventory of 1750. (86)

57

GAMES BOARD

Venice, early 14th century
Inlaid wood, miniatures, and painted clay
reliefs under rock-crystal, jasper, chalcedony,
bone; 38 × 38 cm
The pictures show motifs from chivalry
without thematic coherence. Listed in the
Ambras Collection inventory of 1596. (168)

OCTAGONAL JEWEL CASKET

**Workshop of Baldassare degli Embriachi,
Venice, late 14th/early 15th century**
Wood with *intarsia* (Italian marquetry), bone;
H 43 cm
Mythological scenes are depicted on the sides.
From the Este Collection. (8020)

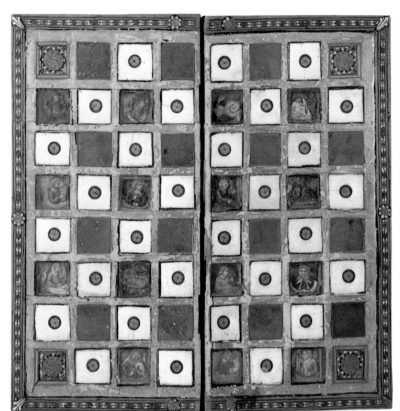

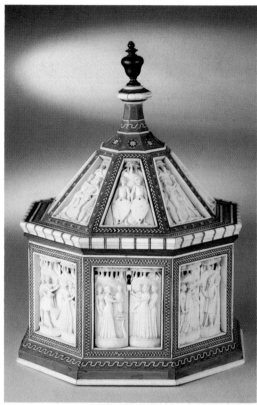

▷

CASKET

French, 2nd half of 14th century
Ivory; L 21 cm, W 10.2 cm, H 7 cm
Depicts scenes from the story of the Châtelaine
de Vergi, a popular troubadour song.
From the Ambras Collection. (115)

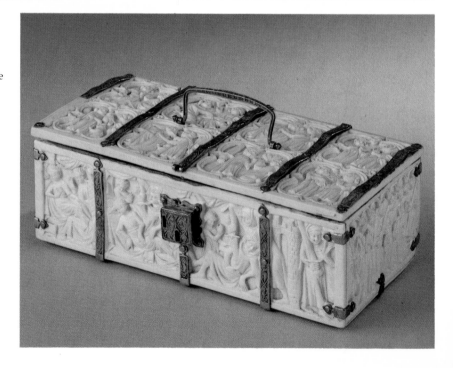

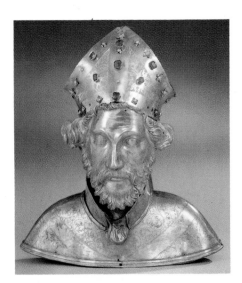

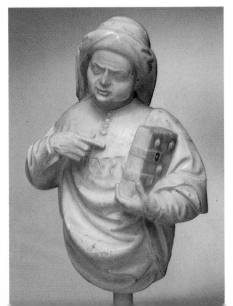

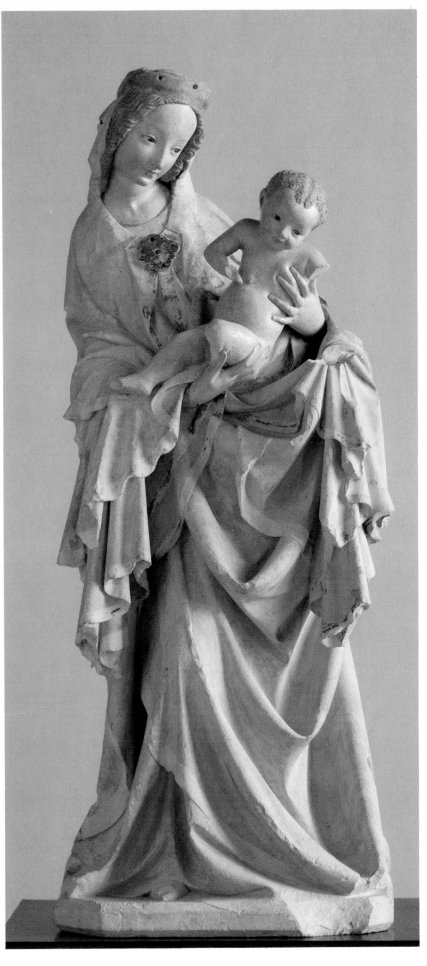

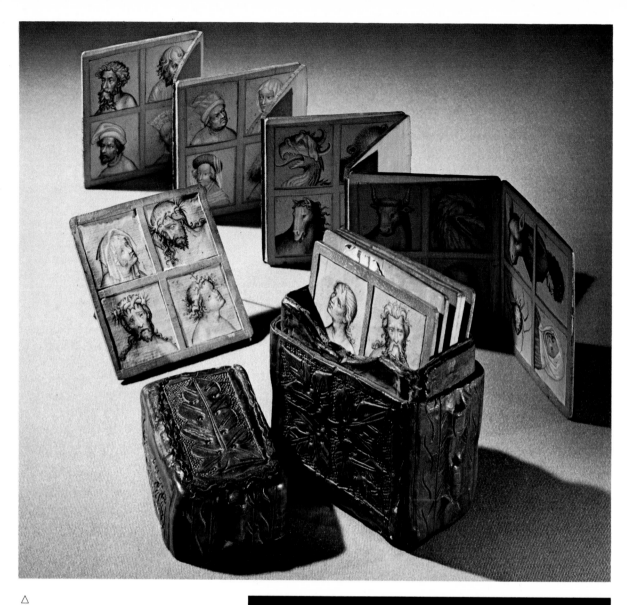

△
THE VIENNA 'MUSTERBUCH' (PATTERN BOOK)
Vienna or Prague, early 15th century
Fifty-six drawings tinted in white and red on
paper in groups of four on small maple panels;
each 9.5 × 9 cm; leather case.
A travelling painter's collection of motifs.
(5003, 5004)

▷

THE 'AMBRAS COURT HUNT PLAYING CARDS'
Upper Rhenish (Circle of Konrad Witz),
c 1440/50
54 playing cards (formerly 56); layers of
paper stuck together, line drawing,
watercolours; each approx 15.6 × 9.5 cm
The four suits are herons, hounds, falcons,
and falcon-lures.
Listed in the inventory of the Ambras
Collection of 1596. (5018–5071)

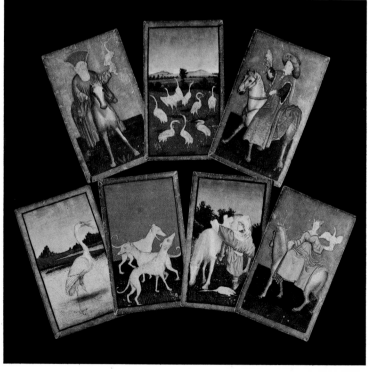

SO-CALLED 'ADDERS' TONGUES CREDENCE'
German, middle of 15th century
Silver-gilt; fossilized sharks' teeth, a single
citrine; *H* 27 cm
The adders' tongues were supposed to give a
warning of poisons in food and drink, and to
neutralize poisons. From the Ambras
Collection. (89)

STATE GOBLET OF EMPEROR FRIEDRICH III
Burgundian, third quarter of 15th century
Silver, parcel-gilt, enamel, rock-crystal;
H 43 cm
Probably a present from Duke Charles the Bold
of Burgundy to the Emperor. Listed in the
inventory of the Ambras Collection of 1596.
(65)

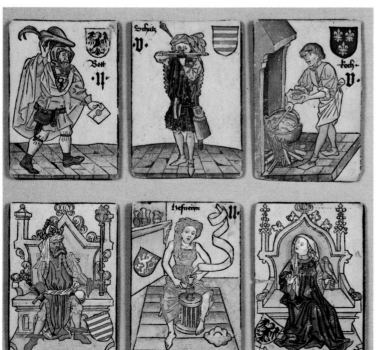

◁

THE 'HOFÄMTERSPIEL' (THE COURT PLAYING
CARDS)
South German, upper Rhenish(?), *c* 1450
Forty-eight playing cards surviving; layers of
paper, woodcut and line drawing, water-
colours, gold and silver leaf; each approx
14 × 10 cm
Representations of occupations and classes
with King and Queen at the top. The suits are
the Imperial coats of arms, and those of
Bohemia, Hungary, and France. Listed in the
inventory of the Ambras Collection of 1596.
(5077–5124)

TWO GOBLETS WITH COVERS
Venetian or Burgundian, c 1440/50
Silver, parcel-gilt, enamelled; *H* 29 and
28.5 cm
The knob on the cover of both has been
replaced.
From the Ambras Collections. (85, 88)

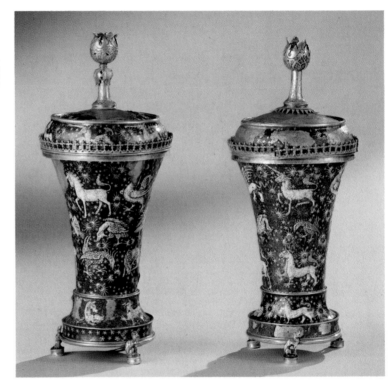

DOUBLE ROCK-CRYSTAL GOBLET
Mount Nürnberg, 2nd half of 15th century
Silver-gilt; *H* 24.5 cm
Taken over from Laxenburg in 1872. (82)

ROCK-CRYSTAL GOBLET AND COVER
**Base mount South German(?), 1449; mount of
cover and rim Graz(?), 1564**
Silver-gilt; *H* 25.7 cm
On the base is the personal mark of Emperor
Friedrich III, AEIOV, and date. Presented by
Archduke Karl II of Inner Austria to his Court
steward Caspar Freiherr zu Herberstein in
1564. (6896)

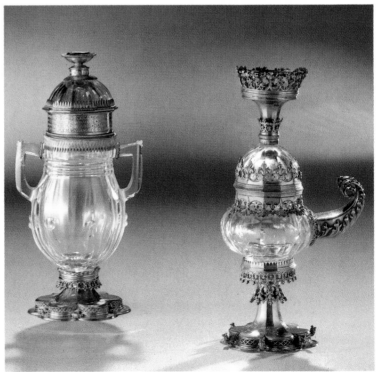

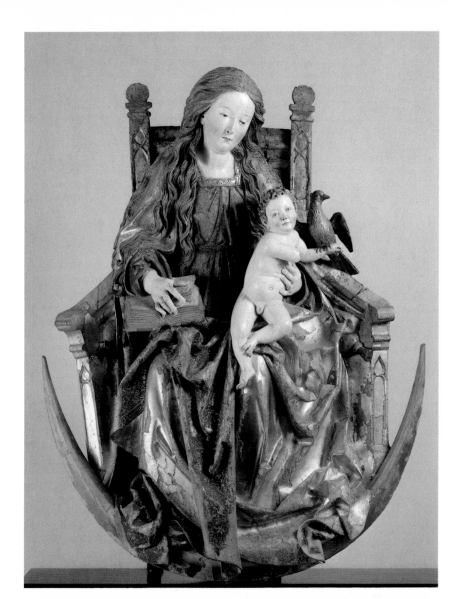

ENTHRONED MADONNA WITH CHILD ON THE
CRESCENT MOON
**Master of the Thalheim altar, Swabian
(Ulm?),** *c* **1510**
Polychromed wood; *H* 112 cm
Acquired in 1862 from the Gasser Collection.
(30)

TROUBADOUR'S BOX
Upper or Middle Rhenish, *c* **1460/70**
Boxwood; *L* 31 cm, *W* 16 cm, *H* 12 cm
On the lid and sides are scenes from the life of
the *Wildleute* (wild men), personifications of
natural forces.
From the Antiquities Room. (118)

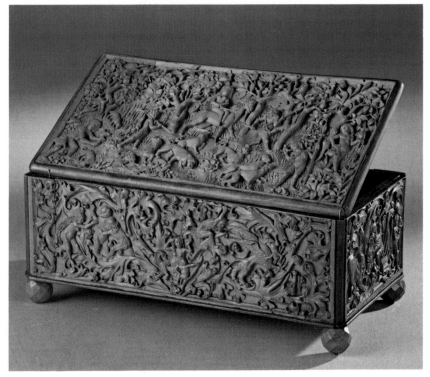

TWO DOUBLE BOWLS
South German, late 15th century
Veined wood, the mount silver-gilt;
left H 18 cm, *right* H 15 cm
The very hard dense-veined wood is the result
of fusions of various deciduous trees and
rootstocks.
From the Ambras Collection and the Gustav
Benda bequest 1932. (73 and 9054)

THE VIRGIN MARY WITH CHILD
**Tilman Riemenschneider (b. Osterode in the
Harz c 1460, d. Würzburg 1531), Würzburg,
c 1505/10**
Polychromed wood; H 145 cm
Taken over from the Austrian Museum for
Applied Arts 1935 (previously came from the
Gasser Collection in 1869). (8899)

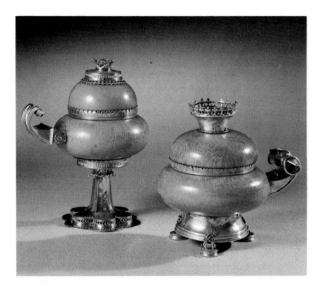

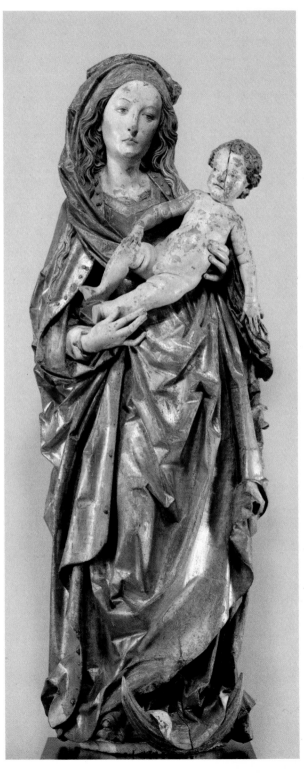

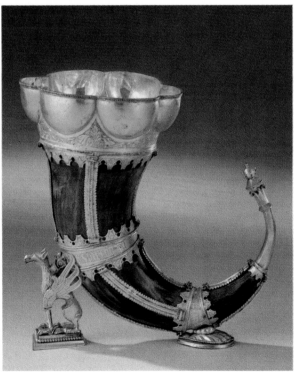

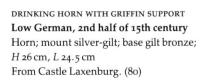

DRINKING HORN WITH GRIFFIN SUPPORT
Low German, 2nd half of 15th century
Horn; mount silver-gilt; base gilt bronze;
H 26 cm, L 24.5 cm
From Castle Laxenburg. (80)

Early and High Renaissance

As a result of the study of Antiquity and Nature, the Renaissance, with its newly acquired self-awareness, focused all its efforts and interest on Man as an individual. Thus a new demand emerged in sculpture for the representation of individual facial features and the corporeality of the human physique.

The discovery of the uniqueness of the individual is expressed above all in the new genre of the portrait. The form of the bust of King Alfonso I of Aragon (p 67), with the head seeming to emerge from an empty suit of armour, was unusual for the middle of the fifteenth century and is derived from Roman Imperial likenesses. This form is also to be found on Pisanello's Alfonso medallions, by means of which the King's bust can be definitely identified. Whereas this unknown sculptor extols the princely man of power, Francesco Laurana in his portrait of a Princess of Aragon (p 70) concentrates on an almost abstract, firm, yet extremely sensitive line, in order to bring out the majestic aloofness of his tender model. Doubt has rightly been cast on the former identification of the subject as Isabella of Aragon, the great granddaughter of Alfonso I.

The 'Polyhymnia' by Tagliacarne (p 69) is, on the other hand, an idealized head, fashioned on antique lines with large surfaces, whose smooth face makes a happy contrast to the rough, unfinished, yet picturesque garland of flowers. The use of hard porphyry, the Imperial stone of Antiquity, is designed to present the great and revered past ages even more vividly. A new theme of the Renaissance which goes back to Hellenic times is that of the child, the *putto*. Desiderio da Settignano's 'Laughing Boy' and the *putto* with fig and grapes by an anonymous Florentine artist (both p 67), are truly pictures drawn from life.

Alongside the profane themes, which played an increasingly important rôle, religious assignments naturally continued to exist. Because of a new self-awareness, however, the Holy figures and Biblical scenes were brought out of their sacred remoteness and placed firmly on earth. Antonio Rossellino's 'Madonna' is a tender mother with her child (p 68); and in the Entombment of Christ (p 69), the people depicted appear to feel the real grief and deep mourning of close friends and relatives, even when they express these in antique gestures.

Another new creation of the Renaissance was the bronze statuette as an independent work of art, made for collectors and connoisseurs. Like gem-carving, this artistic genre grew out of the humanists' interest in antiquities. In this sphere the Vienna Collection has a great artistic unity and in size and importance can scarcely be surpassed by any other collection. One of the most significant works of the early Renaissance is Bertoldo's 'Bellerophon' (p 68), whose severe profile gives the impression that it was modelled on an ancient sarcophagus relief. Bertoldo was the custodian of the Medici collection of antiquities and had an important mediating rôle as the disciple and the teacher of Michelangelo.

The collection has whole sets of works of the north Italian masters of this time. In the forefront of these is Antico, whose real name was Pier Jacopo Alari Buonacolsi and who deliberately adopted this demonstrative pseudonym. His bronzes are in many cases variations after antique sculptures. The life-size busts of Bacchus and Ariadne (p 71) represent the peak of his production in the antique style. It is interesting to compare the classical beauty of their heads and their absorbed remoteness with Tullio Lombardi's *Paar alla antica* (couple in antique style) (p 70), who appear astonishingly life-like as they turn towards each other. With various evocations of Rome, such as the figure of *Venus felix* after a statue in the Vatican or the 'Hercules and Antaeus' also after a former Vatican antiquity (both p 71), Antico created a copy of the splendour of Ancient Rome for the art room of the Marchioness Isabella d'Este (1474–1539) in Mantua. Moderno, whose true identity is unknown, no doubt chose his pseudonym in contrast to Antico. He incorporated antique motives into his modern compositions, as is shown in his two silver reliefs from the period of his work at the Papal Mint in Rome (p 73). Andrea Riccio was at first influenced by the art of Donatello. The graphic realism of his early period, as seen in the 'Woodcutter resting' (p 72), is toned down when he borrows from Hellenic sculpture, as seen in the 'Boy with Goose' (p 73), and is then expressed only in the extremely careful chasing of the surface.

The German Renaissance is also represented in the Collection of sculpture and decorative arts with outstanding works. The bourgeois Imperial cities of Nürnberg and Augsburg were centres of artistic development in the time of Albrecht Dürer (1471–1528) and Emperor Maximilian I (reigned 1493–1519). Outstanding ability in an exact observation and description of nature was clearly moving in the direction of the aspirations to classical form of the Italian Renaissance.

The old theme of *Vanitas*, the allegory of the transience of all earthly things, was expressed by Gregor Erhart around 1500 by means of naked human figures (p 75), which are nevertheless rooted in the Late Gothic style which was drawing to a close. On the other hand, this fine, close-up group already has the intimate quality of a *Kunstkammer* piece, geared to the connoisseur and amateur as collector. With wise perceptiveness, Albert Ilg selected it out of the scores of treasures with which he was surrounded in the newly installed Museum for the place at the top of the inventory of 1893, a judgement which is still valid today. At the time no one could escape the influence of Dürer's intense creative power. Even the goldsmiths' art in Nürnberg was influenced by the master, who had first learned this craft from his father and by whom a series of designs for goblets has been preserved. One of the goblets in the large group of Nürnberg works in the Collection is traditionally named after Dürer (p 75), because the rounded contours which emerge organically, leading to a flexibly bulb-

ous domed outline, are so close to his sketches that the design must rank as his invention. In Maximilian's goblet (p 75), the outline has hardened and the contours, which have developed into naturalistic pear shapes, are merely superimposed on the form. A leading goldsmith at this time in Nürnberg was Ludwig Krug, who was also active as a sculptor, painter, and copper engraver. His goblets (p 76), in which the Renaissance tendency to accentuate the horizontal is more strongly marked, also hark back to Dürer's inspiration. Peter Flötner, who had been working in Nürnberg since 1522, occupied an outstanding position in the statuary art of the city. The 'Adam' (p. 78) is the only wooden figure which has so far been authenticated as his work, and it may have served as a model for a bronze cast.

In Augsburg, Hans Daucher was one of the sculptors in whose work the ideas of the Renaissance took on plastic form. He was a pupil of Gregor Erhart, but the art of Albrecht Dürer and the Italian rules of form exerted a greater influence over him. A woodcut by the Nürnberg master is the basis of the Annunciation (p 77). Recent research shows Daucher's work to be considerably more extensive: 'Cupids playing' (p 77) and portraits on box lids, one of which is reproduced here (p 78), have recently been attributed to him. An Augsburg master must also have made the stone medallion with the likeness of Elisabeth von Hessen (p 78), which is one of the Collection's latest acquisitions. Conrat Meit and Christoph Weiditz come to grips with the representation of nudes in their Adam and Eve statuettes (pp 78, 79). Meit, a native of Worms, who was at first also under the influence of Dürer's art, went to Mecheln in 1512 in the service of Margaret of Austria, the Regent of the Netherlands, and settled in Antwerp in 1534. Weiditz, who had been resident in Augsburg since 1526, travelled to Spain and the Netherlands in the service of Charles v and must also have known Italy. The two precious figures belong to his most mannered style in his late phase. Out of these artistic interweavings from all parts of Europe a new style was born, examples of which will be introduced in the following section.

One of the highlights of the South German 'Little Masters' art' of the Renaissance is the backgammon board which Hans Kels the Elder made for Emperor Ferdinand I in 1537 (p 79). The outer side is adorned with equestrian portraits of Charles v and Ferdinand I, surrounded by likenesses of their forebears and kinsmen and also by coats of arms from the Hapsburg demesne. In the corners on Ferdinand's side are the Assyrian Ninus, the Persian Cyrus, Alexander, and Romulus, representing the four great world monarchies; on Charles v's side are the Romans, Caesar, Augustus, Trajan, and Constantine. The sequence, which also includes mythological scenes and Old Testament heroes and kings on the thirty-two playing pieces which go with the board, was no doubt worked out by a learned humanist. The extremely fine ornamentation rules out any possibility of practical use and makes the board a virtuoso *Kunstkammer* piece.

▷

LAUGHING BOY
Desiderio da Settignano (b. and d. in Florence *c* 1430–64), Florence, *c* 1455
Marble; *H* 33 cm
Gustav Benda bequest 1932. (9104).

ALFONSO I OF ARAGON, KING OF NAPLES
Naples, middle of 15th century
Marble; *H* 96 cm
Acquired 1834 from private owner. (5441).

PUTTO WITH FIG AND GRAPES
Florence, late 15th century
Painted terracotta; *H* 65 cm
Gustav Benda bequest 1932. (9111)

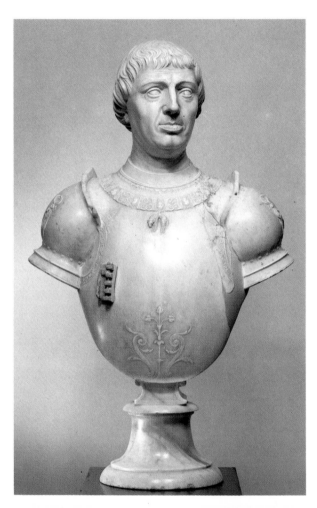

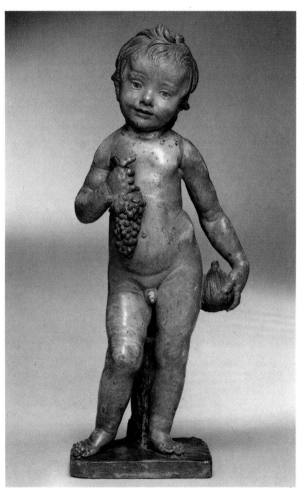

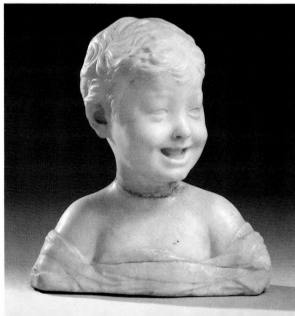

67

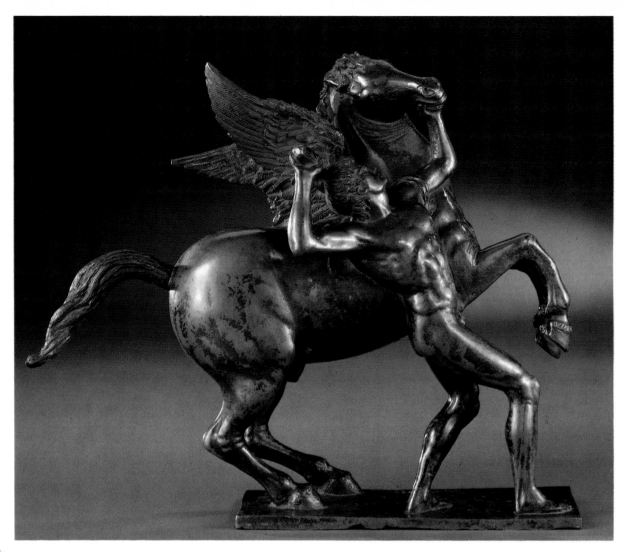

BELLEROPHON TAMING PEGASUS
**Bertoldo di Giovanni (b. *c* 1420, d. 1491
Poggio a Caiano near Florence), Florence,
c 1480/84**
Bronze, signed; *H* 32.5 cm
Cast by Adriano Fiorentino (*c* 1440/50–99),
who worked with Bertoldo from 1480 until
1484.
From the Antiquities Room (1781 in the
collection De France). (5596)

▷
MADONNA WITH CHILD
**Antonio Rossellino (b. and d. Florence
1427–79), Florence, *c* 1465/70**
Marble; 69.5 × 52 cm
Taken to Ambras by Claudia de Medici in
1626. (5455)

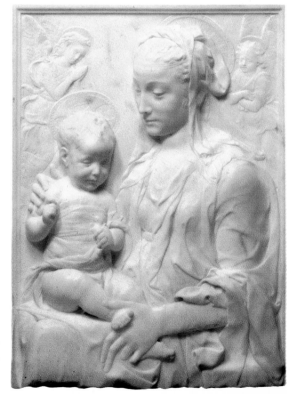

ENTOMBMENT OF CHRIST
North Italy (Padua or Mantua), *c* **1480**
Bronze, parcel-gilt; 24.3 × 44.5 cm
The relief is closely reminiscent of the art of
Andrea Mantegna. Listed in the inventory of
the art collection of Archduke Leopold
Wilhelm of 1659. (6059).

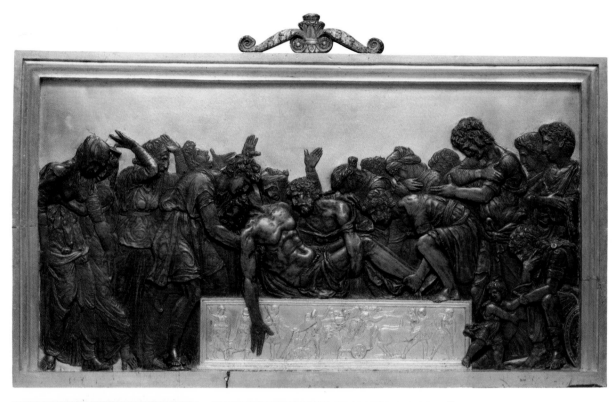

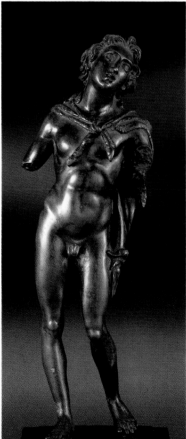

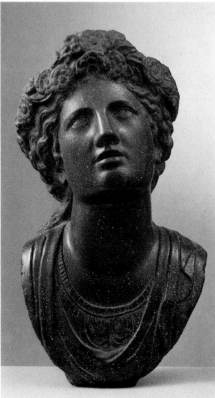

◁
POLYHYMNIA
**Pier Maria Serbaldi della Pescia, called
Tagliacarne (b. 1454/5, worked in Florence
and Rome, Master of the Papal Mint 1515),
Florence,** *c* **1500**
Porphyry; *H* 42.5 cm
From the Antiquities Room. (3529)

◁ ◁
APOLLO(?)
Florence, late 15th/early 16th century
Bronze; *H* 25.5 cm
From the Ambras Collection. (5593)

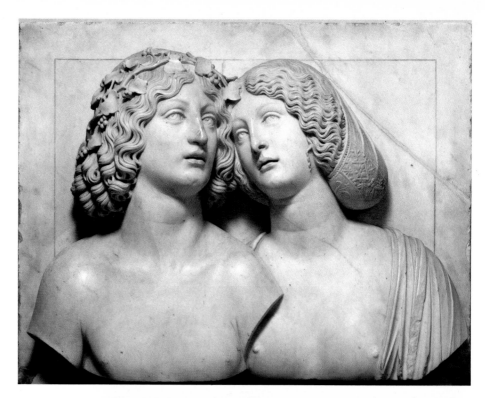

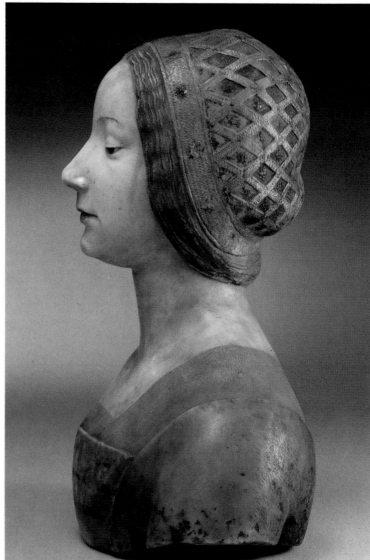

△
YOUNG COUPLE AS BACCHUS AND ARIADNE
Tullio Lombardi (b. and d. Venice *c* 1455–1532), Venice *c* 1505
Marble; 55 × 71 cm
From the Este Collection. (7471)

▷
PORTRAIT OF A PRINCESS FROM THE HOUSE OF ARAGON
Francesco Laurana (b. Vrana near Zara *c* 1430, d. France 1502), Naples, between 1483 and 1498
Polychromed marble; *H* 44 cm
The bust was produced during Laurana's third stay in Naples. From the Treasury. (3405)

BACCHUS AND ARIADNE

Pier Jacopo Alari Buonacolsi, called Antico (b. Mantua(?) c 1460, d. Gazzuoli near Mantua 1528), Mantua, early 16th century

Bronze; *H* 59 and 50 cm

Listed as Bacchus in the inventory of Archduke Leopold Wilhelm's collection of 1659. From the Antiquities Room. (5987 and 5991)

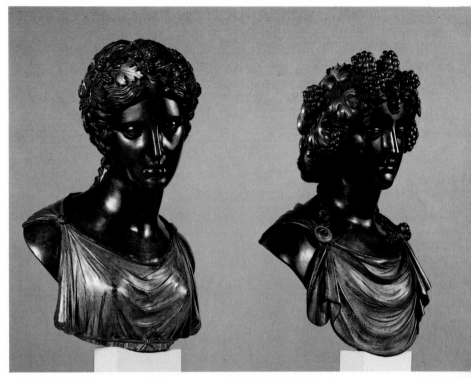

▷

VENUS FELIX

Pier Jacopo Alari Buonacolsi, called Antico (b. Mantua c 1460, d. Gazzuoli near Mantua 1528), Mantua, early 16th century

Bronze, hair and robe fire-gilt; *H* with pedestal 32 cm

Ten ancient coins are set into the base. The statuette is a variation after an antique marble Venus in the Vatican.

From the Antiquities Room. (5726)

▷ ▷

HERCULES AND ANTAEUS

Pier Jacopo Alari Buonacolsi, called Antico (b. Mantua(?) c 1460, d. Gazzuoli near Mantua 1528), Mantua, early 16th century

Bronze; 43.5 cm

After an antique model. According to the inscription, the sculpture formerly belonged to Marchioness Isabella d'Este (1474–1539), Mantua, authenticated.

Listed in the inventory of the art collection of Archduke Leopold Wilhelm of 1659. (5767)

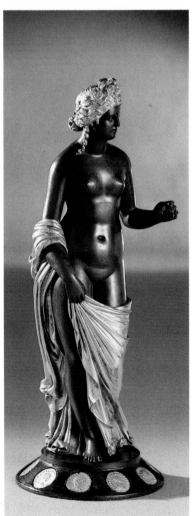

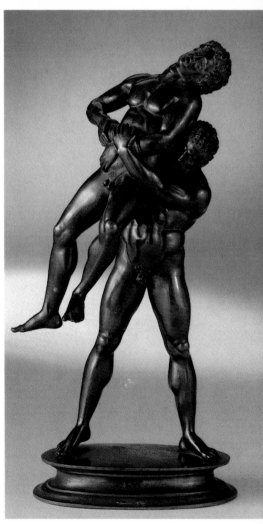

VENUS
Tullio Lombardi (b. and d. Venice *c* 1455–1532), Venice, early 16th century
Bronze; *H* 23 cm
The statuette was conceived as a torso inspired by antique sculpture.
From the Ambras Collection. (5600)

WALKING YOUTH
North Italy(?), early 16th century
Bronze; *H* 71.5 cm
Originally in the Caerino dei Cesari of the Palazzo Ducale in Mantua.
From the collection of Archduke Leopold Wilhelm. (6023)

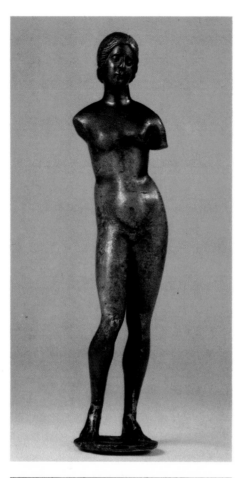

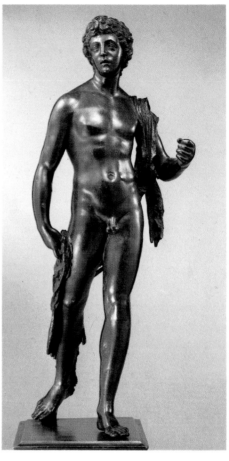

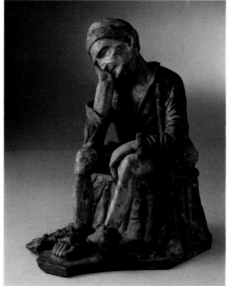

◁
WOODCUTTER RESTING
Andrea Riccio (b. Trient between 1460 and 1465, d. Padua 1532), Padua, *c* 1500
Mounted on polychromed terracotta; *H* 37 cm
The realistically formed figure sits in the attitude of a Christ in repose. Donated in 1920 by Prince Johannes II of Liechtenstein. (7345)

▷
BOY WITH GOOSE
Andrea Riccio (b. Trient between 1460 and 1465, d. Padua 1532), Padua, *c* 1515
Bronze; *H* 19.6 cm
After a Hellenistic model.
From the Antiquities Room. (5518)

FLAGELLATION OF CHRIST
**Moderno (pseudonym of a goldsmith
working in North Italy and Rome in late
15th/early 16th century), Rome, *c* 1538/9**
Silver, parcel-gilt; 13.9 × 10.3 cm
The figure of Christ is inspired by the Laokoon
discovered in 1506. Taken over from Castle
Laxenburg. (1105)

SACRA CONVERSATIONE (MADONNA WITH SAINTS)
**Moderno (pseudonym of a goldsmith
working in North Italy and Rome in the late
15th/early 16th century), Rome *c* 1538/9**
Silver, parcel-gilt; 13.9 × 10.2 cm
Companion-piece to the 'Scourging of Christ',
with several features inspired by the antique.
Taken over in 1872 from Castle Laxenburg.
(1107)

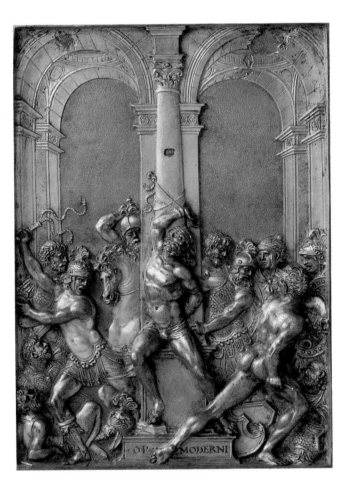

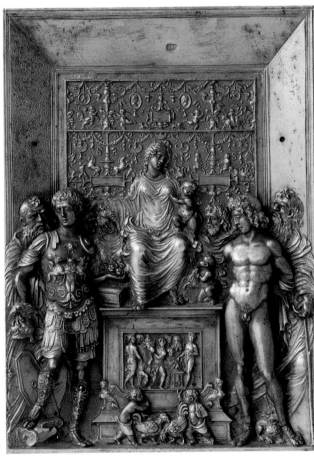

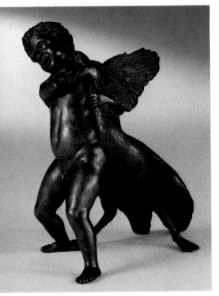

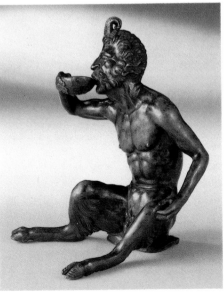

◁

SATYR
**Andrea Riccio (b. Trient between 1460 and
1465, d. Padua 1532), Padua, early 16th
century**
Bronze; *H* 21.7 cm
From the Antiquities Room. (5539)

BAPTISM OF CHRIST

Netherlandish (Brussels?), early 16th century
Tapestry of wool, silk, gold, and silver thread;
200 × 175 cm
Composition of the main group after Rogier
van der Weyden's *Johannesaltar* (altar of St
John) in Berlin.
Old Imperial property. (xxx/2)

**Two tapestries from a series of six, French,
early 16th century**
Wool and silk
Triumph of Death over Chastity, section: Pandora;
4.14 × 5.42 m
Old Imperial property.
*Triumph of Fame over Death, section; Emperor
Charlemagne;* 4.20 × 5.64 m
Old Imperial property.(CII/3 and II/4)

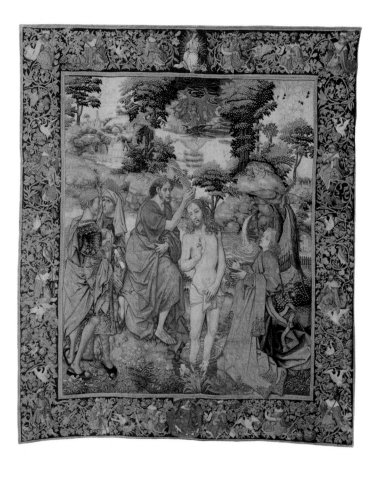

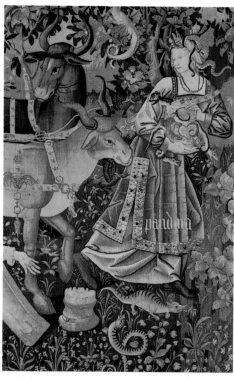

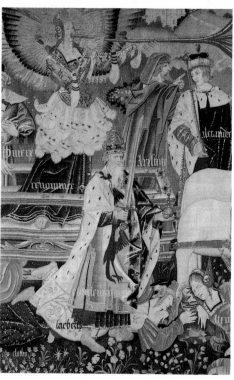

ALLEGORY OF VANITY

Gregor Erhart (b. Ulm *c* 1465, d. Augsburg 1540), Augsburg, *c* 1500

Limewood with old polychrome; *H* 46 cm
A youth, a maiden, and an old woman, in whom the signs of physical degeneration are all too obvious, are a parable for the transience of earthly things. Acquired in 1861 from the Monastery of St Florian. (1)

▷▷

GOBLET WITH COVER (SO-CALLED 'DÜRER GOBLET')

Nürnberg, *c* 1500

Silver-gilt; *H* 47.8 cm
Probably based on sketches by Albrecht Dürer. Listed in the inventory of the Ambras Collection of 1596. (109)

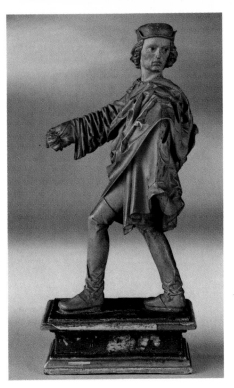

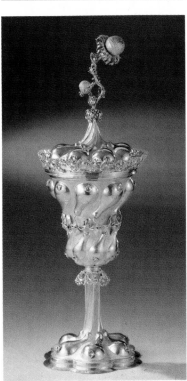

FALCONER

Anton Pilgram (b. Brünn(?) *c* 1450/60, d. Vienna(?) *c* 1515), *c* 1500

Pearwood; hood, eyes, and base stained; *H* 31.3 cm
From the Ambras Collection. (3968)

▷▷

GOBLET WITH COVER (SO-CALLED 'MAXIMILIAN GOBLET)

Nürnberg *c* 1510

Silver-gilt; enamelled Imperial coat of arms on inside of cover; *H* 56 cm
The goblet is supposed by old tradition to have come from Emperor Maximilian's Estate. Listed in the inventory of the Ambras Collection of 1596. (110)

TWO GOBLETS WITH COVERS
**Ludwig Krug (worked in Nürnberg from
1514, d. there 1532), Nürnberg, *c* 1520/30**
Silver-gilt; *H* 44 cm and 32 cm
Listed in the inventory of the Ambras
Collection of 1596. (898, 879)

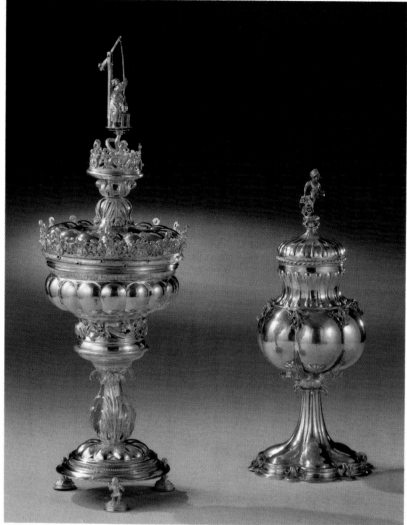

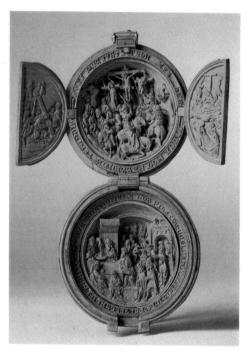

△

PRAYER NUT
Low German, early 16th century
Boxwood; *Diam* 6.2 cm
Miniature carving, showing the crucifixion
(*above*); Christ before Pilate and Flagellation
(*below*).
From the Treasury. (4206)

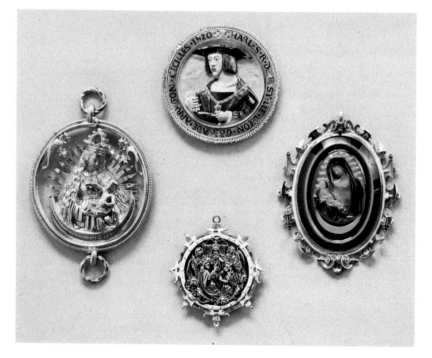

EMPEROR MAXIMILIAN I AS ST GEORGE
Hans Daucher (b. Ulm *c* 1486, d. Stuttgart 1538), Augsburg, *c* 1520/5
Solnhofen limestone; 23 × 15.5 cm
With initials, inscription: IM[PERATOR] CAES[AR] MAXIMILIANUS AUGUSTU(S)
Gustav Benda bequest, 1932. (7236)

THE ANNUNCIATION
Hans Daucher (b. Ulm *c* 1486, d. Stuttgart 1538), *c* 1510
Solnhofen limestone; 18 × 15 cm, with initials
Acquired on the art-market. (4422)

◁

JEWELLERY

Above centre: Hat-buckle (medallion), depicting Emperor Charles v
Spanish or French, 1520
Gold, enamel; *Diam* 5.72 cm
Inscription: CHARLES R(OI) DE CASTILLE LEON GRENADE ARAGON CECILLES 1520

Below centre: Pendant, 'Coronation of Mary'
German, late 15th century, mount *c* 1600
Silver, parcel-gilt and enamel, in gold and enamel frame; *Diam* 4.6 cm
Both pieces from the Treasury. (1610 and 132)

Left: Pendant, 'Mary and Child on the crescent moon'
South German, *c* 1510
Silver, parcel-gilt; *Diam* including rings 9 cm
Gustav Benda bequest 1932.

Right: Pendant, Mary and Child
Netherlandish, 1st half 15th century
Onyx; mount gold and enamel, 2nd half of 16th century; *H* 7.5 cm, *W* 6 cm
Listed in Treasury inventory of 1750.
(9024 and XII 10)

CUPIDS PLAYING
Hans Daucher (b. Ulm *c* 1486, d. Stuttgart, 1538), Augsburg, *c* 1520
Pearwood; *H* 42 cm, *W* 76 cm
The Cupids symbolize human passions.
Taken over from the Court Library, 1908.
(8920)

ADAM AND EVE
Conrat Meit (b. Worms *c* 1475/80, d. Antwerp 1550/1), *c* 1520/5
Boxwood; *H* 25.5 and 24 cm
Taken over from the Austrian Museum of Applied Arts. (9888 and 9889)

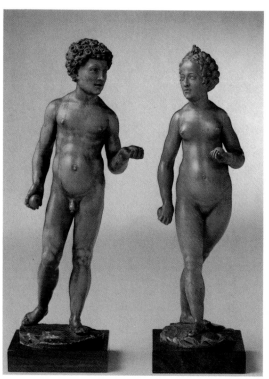

◁

ADAM
Peter Flötner (b. Switzerland(?) *c* 1485, d. Nürnberg 1546), Nürnberg, *c* 1525
Boxwood; *H* 34.5 cm with monogram
Acquired from the collection of Victor von Miller, Vienna, 1872. (3896)

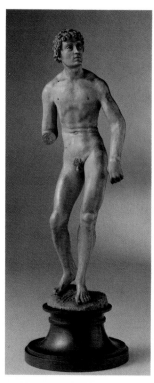

◁

BOX, BUST PORTRAIT OF PRINCE FRIEDRICH *DER WEISE* (THE WISE) OF SAXONY
Hans Daucher, (b. Ulm *c* 1486, d. Stuttgart 1538), Augsburg, 1525
Walnut; portrait pearwood; *Diam* 22 cm
Inscription, HERZOG FRIDRICH CURFURST IN SASEN 1525. The portrait is after a Dürer engraving of 1524.
From the collection of Archduke Leopold Wilhelm. (3878)

ELISABETH VON HESSEN
Augsburg master(?), dated 1519
Solnhofen stone; *Diam* 16.8 cm
Inscription, ELISABET LANTG [ÄFIN] Z [U] HESSEN. Elisabeth married Duke Johann of Saxony in 1519, hence the monogram I and E and love knots.
Acquired on the art-market in 1979. (10129)

▷

EMPEROR CHARLES V
South German, *c* 1530/5
Alabaster with traces of polychrome; beads; *H* 14.2 cm, *W* 12.9 cm
Originally probably on a polychrome stone base.
Acquired 1808 from the De France Collection. (XIIa82)

ADAM AND EVE
Christoph Weiditz (b. Strassburg or Freiburg
c 1500, d. Augsburg 1559), Augsburg c 1540/50
Pearwood; H 32 cm and 31.2 cm
From the Ambras Collection. (3965 and 3967)

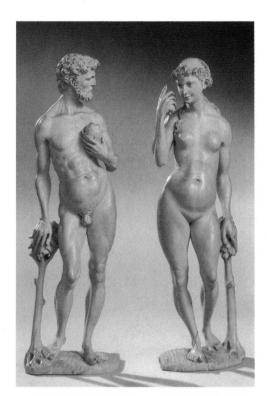

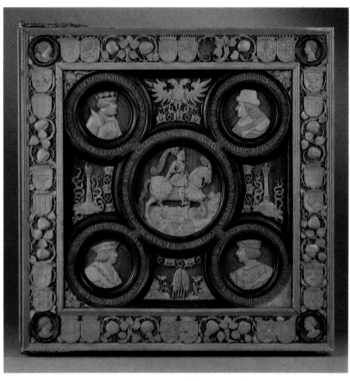

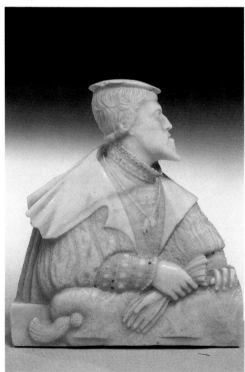

BACKGAMMON BOARD, OUTER SIDE
Hans Kels the Elder (b. c 1480, d.
Kaufbeuren 1559/60), signed and dated 1537
Oak, walnut, boxwood, Hungarian veined
ashwood; 56.1 × 56.1 cm
In the centre is an equestrian portrait of
Charles v, surrounded by portrait medallions
of his forebears Albrecht II, Friedrich III,
Maximilian I, and Philip the Handsome. With
the board are 32 draughtsmen with
predominately mythological scenes.
Listed in the Treasury inventory of 1750. (3419)

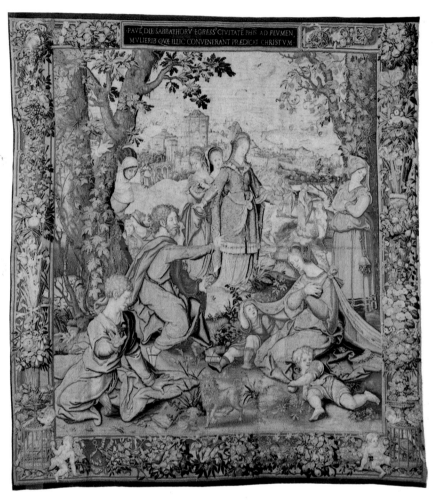

SCENES FROM THE LIFE OF ST PAUL
Brussels, *c* 1540
Tapestry of wool, silk, gold and silver thread;
417 × 383 cm
Inscription in the upper border in translation:
'Paul is leaving the city of Philippi on the
Sabbath, going in the direction of the river and
is preaching Christianity there to the
assembled women'.
From the Estate of Emperor Franz I (died
1765). (III/1)

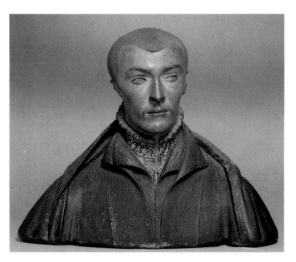

BUST OF A YOUNG MAN
Upper Rhenish(?), *c* 1540/5
Polychromed terracotta, mounted; *H* 48 cm
Taken over from the Austrian National Library
in 1936. (8919)

Late Renaissance

The late Renaissance art of the period between approximately 1530 and 1600 forms the heart of the Collection of sculpture and decorative arts. Bronzes, goldsmiths' works, and gem-carvings of the highest quality are present in such abundance that the selection of certain pieces rather than others of equal merit could appear invidious. This wealth is accounted for by the history of the Collection and by the general development of the *Kunstkammer* into a vehicle of princely prestige and display of power during this period.

The most famous piece in the collection is Benvenuto Celllini's golden *saliera* (salt-cellar) (p 83). The artist was proud of his cosmographic invention, which he describes in his autobiography (and which is quoted beside the illustration). His description is supplemented in the sequence on the base of the piece, on which the four wind gods, day and night, morning and evening, are recumbent; day and evening are almost identical copies of the same figures on Michelangelo's Medici tombs. Between them lie representations of human activities. Cellini's figures call for a comparison with a roughly contemporary tapestry (p 84), which reproduces the decoration of Francesco Primaticcio in the great gallery of the Royal Palace of Fontainebleau, together with the roof beams and corbel mouldings. The salt-cellar was part of the truly royal gift which Charles IX of France sent to Archduke Ferdinand II in 1570 when the latter represented the King in Speyer at his marriage with Archduchess Elisabeth. Part of the present, which was obviously intended to honour Ferdinand as a collector, were also the Burgundian Court goblet (p 33), the golden Michael goblet, and an onyx ewer (p 82).

Among the portraits, the majestic, carefully-worked bust of Charles V by Leone Leoni (p 85) is the most important work. Emperor Rudolf II had his bust made after this model by Adriaen de Vries (p 105). The unusual lifelike portrait of Philip II by Pompeo Leoni (p 86) was originally placed in a suit of armour designed to give as much verisimilitude as possible. A quite different sort of likeness can be observed in the highly spiritual bronze head of Cardinal Carlo Borromeo (p 85), with its vibrant surface. A stylistic forerunner to this is to be found in the graphic formation of the face in the portrait of a lady by Alessandro Vittoria (p 87).

The collection of bronze statuettes contains a series of the most significant masterpieces of the time. The figure of the youthful Hercules by a Florentine master (p 84) could have been made as an illustration of the theoretical dispute among artists on the question of whether painting or sculpture should be considered the superior art. Cellini decided in favour of sculpture, because in the case of a figure it could deal with many aspects of equal value in the round, whereas painting had to be satisfied with only one. The inclination of the head, the turn of the body, and the poise of the arm in the Hercules challenge the beholder to turn the figure or to walk round it in order to comprehend it fully. Giambologna, the leading master of the second half of the century in Florence, perfects this artistic principle in his *Figura serpentinata*. His main works are the 'Astronomy', the two-figure 'Rape of the Sabines', and the famous 'Flying Mercury' (all p 88), in which weightlessness in sculpture is the primary intention. Sansovino's 'Jupiter' (p 84), Vittoria's 'Winter', (p 87), and Cattaneo's *Luna* (p 87) represent the figure art of Venice of the same period.

Vienna has the most extensive collection of vessel gem-carving in the world. The precious ewers, bowls, or goblets in rock-crystal, lapis lazuli, or prase (quartz) (pp 89–90) were among the *Kunstkammer* pieces most in demand. It must be remembered that in them the aesthetic value of the noble minerals combined with a virtuoso command of the brittle material to yield the most exquisite artistic creations. Milan developed into the uncontested centre of the gem-carvers' art and also of cameos (p 92), which served the whole of Europe. Over a long period the Miseroni (pp 89, 94) and Saracchi (pp 89, 91) families constituted the leading workshops. Artists from Milan also worked in the Florentine workshops founded by Francesco I. Masterpieces of this Court studio are the Lapis-lazuli pail (p 90) and the famous Florentine portable altar (p 94), both of which were mounted by the goldsmith Jaques Bylivelt. The frame of the portable altar is completely independent of the Biblical theme of the *commesso* picture and could just as easily surround a depiction of 'Diana Bathing'. A *commesso* is a type of marquetry picture, composed of precious stones in the manner of *intarsia*.

The increasing need of the Courts for prestige also explains the uncommonly sumptuous tapestries which are richly interwoven with gold and silver thread (pp 80, 84, 91, 93–6). In this field Brussels held absolute pride of place.

'MICHAEL' GOBLET
Paris or Antwerp, *c* 1530/40
Gold; diamonds, emeralds, rubies, pearls;
H 51.7 cm
A present from King Charles IX of France to
Archduke Ferdinand II in 1570. Listed in the
inventory of the Ambras Collection of 1596.
(1120)

ONYX EWER
Paris, *c* 1560/70
Mount gold enamelled; diamonds, emeralds,
rubies; *H* 27.1 cm
A present from King Charles IX of France to
Archduke Ferdinand II in 1570.
Listed in the inventory of the Ambras
Collection of 1596. (1096)

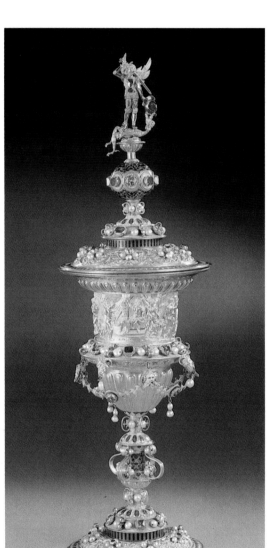

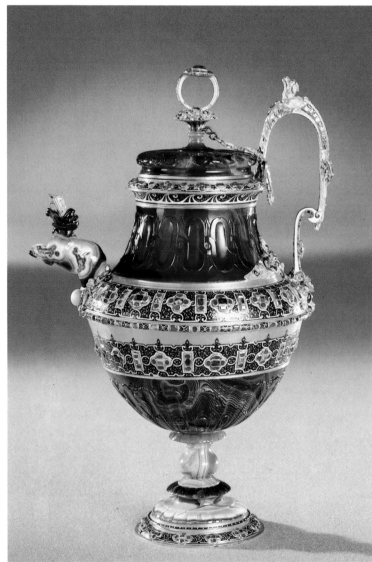

SALIERA (SALT-CELLAR)
**Benvenuto Cellini (b. and d. Florence
1500–72), 1540–3.**
Gold, part enamelled; ivory base; *H* 26 cm,
L 33.5 cm
Made for King François I of France. The little
ship served as a salt-cellar. The sea-god
Neptune, who is dispensing the salt, sits
opposite Tellus, the goddess of the Earth, with
spices.

A present from King Charles IX of France to
Archduke Ferdinand II (of Tirol) in 1570.
Listed in the inventory of the Ambras
Collection of 1596. (881)

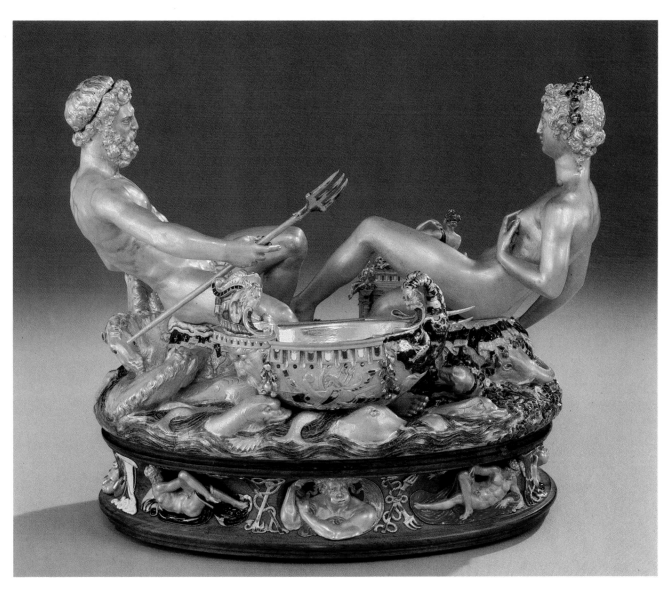

EXTRACT FROM *THE LIFE OF BENVENUTO CELLINI: A FLORENTINE
ARTIST*, WRITTEN BY HIMSELF, TRANSLATED INTO ENGLISH BY
ANNE MACDONELL (DENT, 1926)

*At once he [François I] began to speak to me, saying, that since he had
such a beautiful basin and jug from my hand, he wished for a fine salt-
cellar to keep them company. So he asked me to make him a design for
one, and without delay. I answered, 'Your Majesty will see such a
design sooner than you expect; for while I was making the basin, I
thought a salt-cellar should be made to go with it; so the thing is ready,
and, if it please you, I can show it to you now.' . . . Off I went, and
speedily returned; for I had but to cross the Seine. I brought back with*

*me a wax model, which I had already made at the request of the
Cardinal of Ferrara in Rome. When I uncovered it, his Majesty
exclaimed in his astonishment, 'This is a hundred times more divine
than I could ever have imagined. The man is a wonder! He should
never lay down his tools.' Then turning to me with a most joyful face,
he said that the model pleased him very much, and that he would like
me to carry it out in gold. The Cardinal of Ferrara, who was present,
gave me a look as if to say he recognised the design as the one I had
made for him in Rome. So I reminded him of what I had said before –
that I should make it for him who was destined to possess it. . . . Next
morning I set to work on the fine salt-cellar, and threw the greatest
energy into this and my other works.*

Jacopo Sansovino (b. Florence 1486, d. Venice 1570), Venice, 2nd third of 16th century
Bronze, black lacquer; *H* 43 cm
Illustrated in the pictorial inventory *Prodromus* of 1735. (5655)

▷
YOUNG HERCULES
Florence *c* 1550
Bronze, black lacquer; *H* 38.8 cm
The unknown artist strove to make the figure attractive from several angles.
From the Ambras Collection. (5658)

▽
MYTHOLOGICAL-ALLEGORICAL SCENES: DANAE
Fontainebleau, 1541–50
Tapestry of wool, silk, gold and silver thread; 332 × 625 cm
From a series of six pieces, reproducing the decoration of the great gallery of Fontainebleau.
Mentioned in Vienna in 1690. (CV/1)

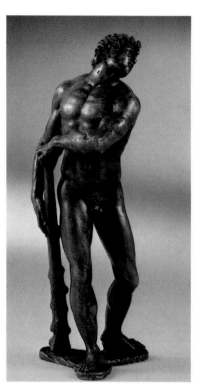

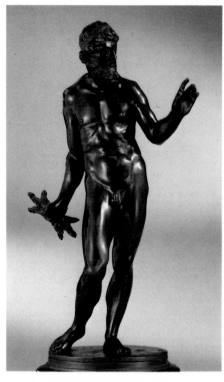

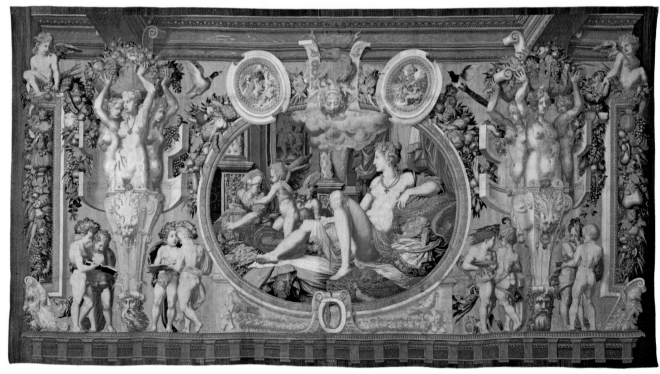

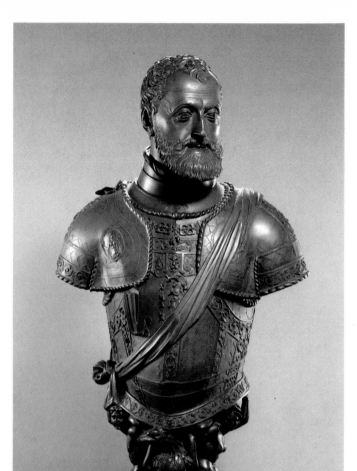

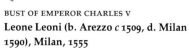

◁

BUST OF EMPEROR CHARLES V
Leone Leoni (b. Arezzo *c* 1509, d. Milan 1590), Milan, 1555
Bronze, natural brown patina; *H* 113 cm
The Emperor is wearing the armour he wore at the Battle of Mühlberg in 1547. Made for Cardinal Granvella, sold to Rudolf II in 1600, carried off to Sweden in 1648, bought back in 1806. (5504)

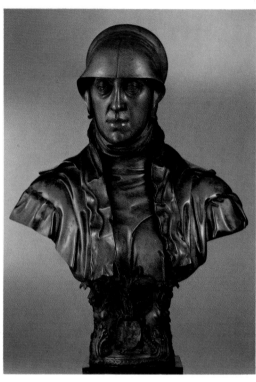

△

BUST OF QUEEN MARIA OF HUNGARY
Leone Leoni (b. Arezzo *c* 1509, d. Milan 1590), Milan, 1555
Bronze, natural brown patina; *H* 67.5 cm
Maria, Charles v's sister, is depicted in mourning. Made at the same time as the bust of the Emperor for Cardinal Granvella.
Same provenance as bust of Charles v. (5496)

◁

PORTRAIT-HEAD OF CARDINAL CARLO BORROMEO
Milan, beginning of 17th century
Bronze, natural brown patina; *H* 25 cm
Cardinal Borromeo (1538–84), Archbishop of Milan, was canonized in 1616.
From the Antiquities Room. (6015)

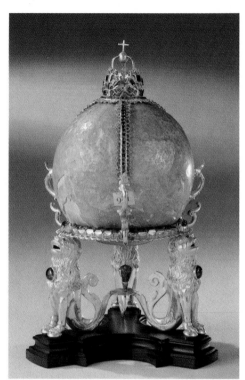

△

PORTRAIT-HEAD OF KING PHILIP II OF SPAIN
**Pompeo Leoni (b. *c* 1533, d. Madrid 1608),
Madrid, *c* 1556**
Painted silver; placed on the polychromed clay
bust of Balthasar Moll in 1753; *H* with bust
62 cm
The head was originally mounted on a dummy
displaying a ceremonial armour.
From the Treasury. (3412)

▷

BEZOAR AND DISH
Spanish, 1st half of 16th century
Mount and dish gold; *H* 21 cm, *Diam* 25.5 cm
The bezoar (from Persian *bâd-sahr*, 'counter-
poison') is formed in the stomach or bowels of
certain ruminants and was considered to be an
effective remedy and antitoxin.
Listed in the Treasury inventory of 1750.
(994 AND 993)

▽

BEZOAR
Spanish, 1st half of 16th century
Mount gold; emeralds, rubies; *H* 20.5 cm
The high-grade gold and the emeralds are of
American origin.
Listed in the Treasury inventory of 1750.
(981)

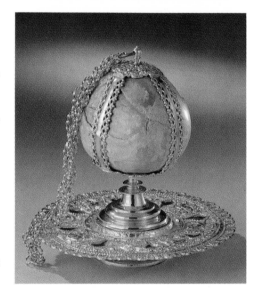

◁ ◁

LUNA
Danese Cattaneo(?) (b. Colomata near Carrara 1509, d. Padua 1573), Venice, *c* 1540/50
Bronze, natural brown patina; *H* 50 cm
Illustrated in the pictorial inventory *Prodromus* of 1735. (5511)

◁

ALLEGORY OF WINTER
Alessandro Vittoria (b. Trient 1525, d. Venice 1608), Venice *c* 1580
Bronze, natural dark-brown patina; *H* 33 cm
From the Antiquities Room. (5664)

PORTRAIT OF A LADY OF THE HOUSE OF ZORZI
Alessandro Vittoria (b. Trient 1525, d. Venice 1608), Venice *c* 1570/80
Terracotta; *H* 83 cm
Taken over in 1942 from the Austrian
Museum of Applied Arts. (9905)

TWO-FIGURE RAPE GROUP
Giambologna (b. Douai 1529, d. Florence 1608), Florence, c 1579
Bronze, natural light-brown patina, dark brown lacquer; H 98.2 cm
Listed in inventory of Emperor Rudolf II's *Kunstkammer* of 1607/11. (6029)

ALLEGORY OF ASTRONOMY OR VENUS URANIA
Giambologna (b. Douai 1529, d. Florence 1608), Florence c 1573
Bronze, fire-gilt; H 38.8 cm
Listed in Treasury inventory of 1750. (5893)

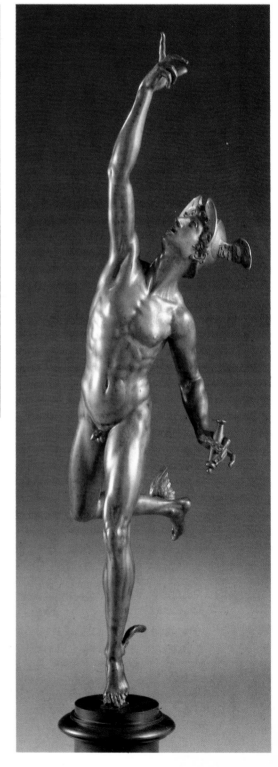

FLYING MERCURY
Giambologna (b. Douai 1529, d. Florence 1608), Florence c 1565
Bronze, natural light patina; H 62.7 cm
The representation of weightlessness combined with a striving for viewability from all angles was new in sculpture.
Listed in the inventory of Emperor Rudolf II's *Kunstkammer* of 1607/11. (5898)

Gasparo Miseroni (b. Milan 1518, d. *c* 1572), Milan, *c* 1560/70

Rock-crystal; mount enamelled gold;
H 23.5 cm, L 30.2 cm
A serpent is winding itself round the shells in this playfully virtuoso mastery of the hard, brittle material.
Listed in the inventory of the Ambras Collection of 1596. (2268)

Italy, 2nd half of 16th century

H 32.9 cm
In the Renaissance, the ancient art of gem-carving was resumed on a grand scale. The rare and precious natural materials served to enhance the princes' prestige.
From the Treasury. (2224)

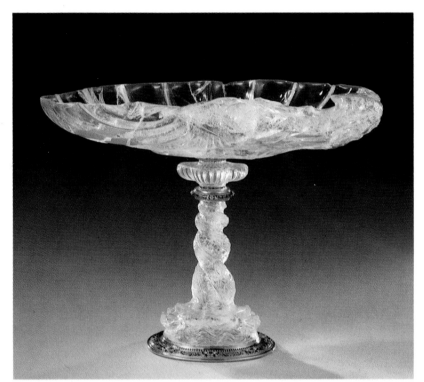

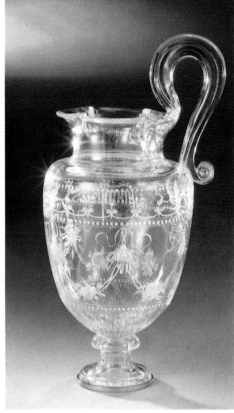

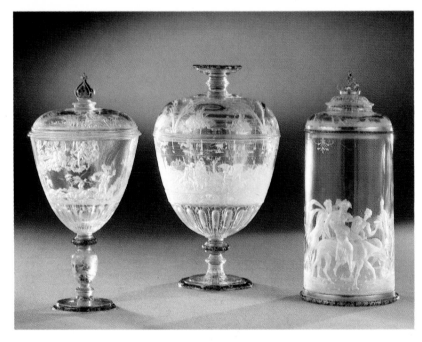

◁

THREE VESSELS IN ROCK-CRYSTAL
Double goblet with scenes from Ovid's Metamorphoses
Milan, *c* 1570
H 25.9 cm
Goblet with cover, depicting the Proserpine myth
Annibale Fontana (b. and d. Milan 1504–87), Milan, *c* 1570
H 23.8 cm
Tankard with lid depicting Bacchanalian procession
Saracchi workshop, Milan, *c* 1585
H 25.1 cm
All mounts enamelled gold.
Listed in the inventory of the Ambras Collection of 1596, or from the Treasury.
(2360, 1415 and 2344)

LAPIS LAZULI PAIL
**Gian Stefano Caroni (d. Florence 1611),
Florence, 1575/6**
Mount and handle enamelled gold, by Jaques
Bylivelt (b. Delft 1550, d. Florence 1603),
Florence, 1576–81
H 36 cm
A present from the Grand Duke Ferdinando II
to Emperor Ferdinand II in 1628. (1655)

LAPIS LAZULI DRAGON BOWL
Milan, *c* 1580
Mount enamelled gold; emeralds, rubies,
pearls; *H* 17 cm, *L* 18.9 cm
Listed in the inventory of Rudolf II's
Kunstkammer of 1607/11. (1851)

PRASE BOWL WITH COVER
Milan, *c* 1580
Mount enamelled gold; onyx cameos, rubies,
pearls; *H* 19.3 cm
Listed in the inventory of Emperor Rudolf II's
Kunstkammer of 1607/11. (2014)

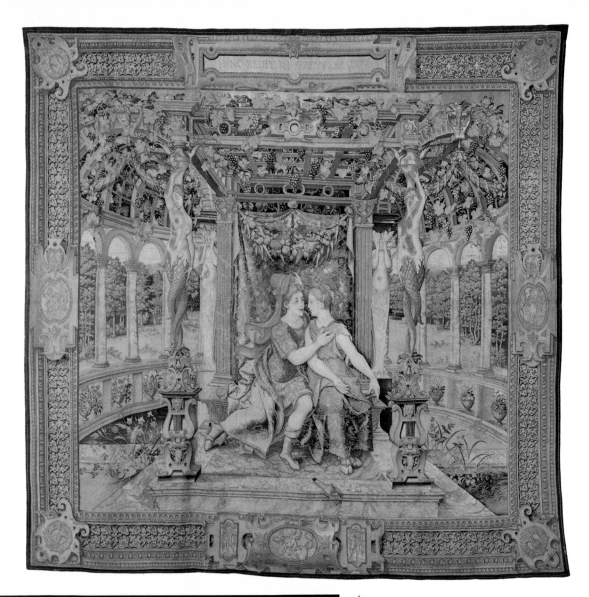

△

THE UNION OF VERTUMNUS AND POMONA
Brussels, mid 16th century
Tapestry made of wool, silk, gold, and silver
thread; 425 × 445 cm
Part of a series of nine tapestries. Based on
Ovid's *Metamorphoses* XIV 623–771. (xx/9)

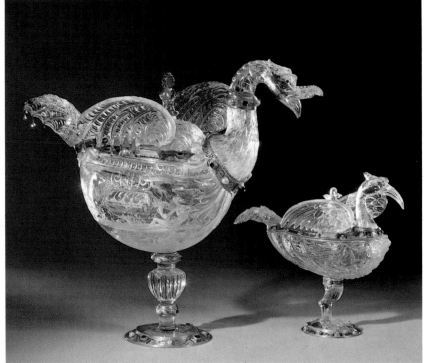

◁

TWO ROCK-CRYSTAL BIRDS (CENTREPIECES)
Saracchi Workshop, Milan, *c* 1580/90
Setting: enamelled gold, emeralds, cameos,
and pearls; *H* 40.9 cm and 23.1 cm
These pieces were described as *Reiger* (herons)
in the old inventories. Originally they had real
aigrettes on their heads. Listed in the
inventory of the Ambras Collection in 1596.
(2401, 2238)

Above centre: Aurora
Jacopo da Trezzo (b. Milan, 1514, d. Madrid, 1589), Madrid(?) late 16th century
Agate; setting: Prague, beginning of 17th century; enamelled gold; 5.4 × 5.7 cm (XII/134)

Above left: Sacrificial death of Marcus Curtius
Francesco Tortorino (worked in second half of 16th century) Milan, late 16th century, signed
Chalcedony; setting: Milan, end of 16th century; enamelled gold, rubies, diamonds, and a single pearl; 4.7 × 4.8 cm (XII/113)

Above right: Juno, Venus, Pallas Athene
Milan, second half of 16th century
Chalcedony; setting: Milan, end of 16th century; enamelled gold, diamonds, and rubies; 4.2 × 4.8 cm (XII/152)

Middle: Leda and the Swan
Italy, late 16th century
Commesso of chalcedony and enamelled gold; diamonds, and rubies; 7.3 × 7.8 cm (XII/123)

Below left: The Emperor Karl v
Southern Netherlands; second half of 16th century
Onyx; setting: Southern Netherlands, end of 16th century enamelled gold and rubies; 5.4 × 4.7 cm (XII/71)

Below right: The Archduchess Johanna, Princess of Portugal (1537–73)
Jacopo da Trezzo (b. Milan 1514, d. Madrid 1589), Madrid, late 16th century
Chalcedony; setting: South German(?), dated 1566; 6.5 × 5.3 cm (XII/70)

Below centre: Diana as a Moor
Milan, second half of 16th century
Jasper, a single pearl, gold, diamonds; setting: Milan(?), early 17th century, enamelled gold, diamonds; 6.1 × 5 cm (XII/120)
All listed in the 1619 Estate inventory of the Emperor Matthias.

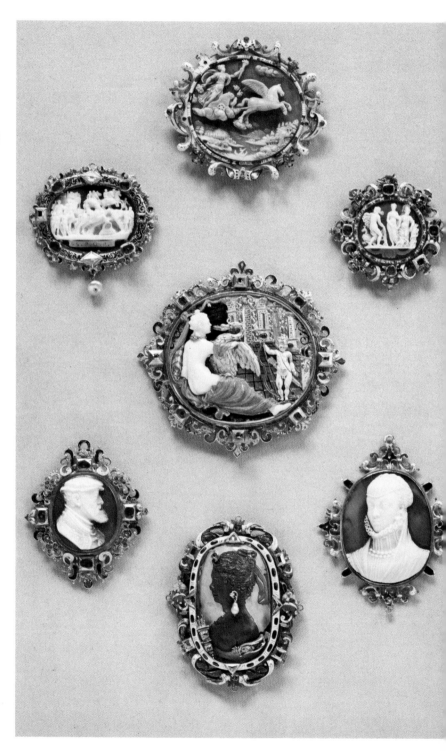

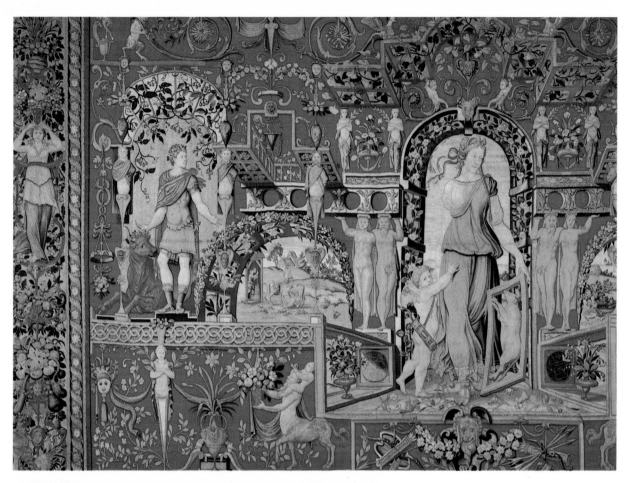

△

THE TWELVE MONTHS, APRIL (SECTION)
Brussels, later than mid 16th century
Tapestry of wool, silk, gold and silver thread;
420 × 610 cm
Venus is the patroness of this month, hence its
sign is Taurus. Through the arch is a vista of
scenes from country life.
From the old Imperial collection. (XI/4)

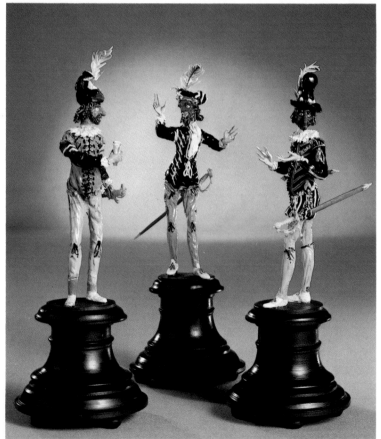

◁

THREE FIGURES FROM THE *COMMEDIA DELL'ARTE*
Venice (Murano) *c* 1600
Stained glass; *H* 21.4 cm, 19.6 cm, and
20.4 cm
The figurines do not conform to the
contemporary style of figures; with all the
eloquence of their gestures they present the
type of the *Capitano* (the military man). Apart
from two such figurines in Copenhagen, no
others have survived.
From the Treasury. (2705, 2711, and 2714)

SMALL HOUSE ALTAR, 'CHRIST AND THE
SAMARITAN WOMAN AT THE WELL OF JACOB'
**Frame of rock crystal by Gian Ambrogio
Caroni (d. Florence 1611); decorations in
enamelled gold by Jacques Bylivelt (b. Delft
1550, d. Florence 1603), completed in 1591;
side niches by Bernardino Gaffuri
(d. Florence 1606), while picture and figures
(*Commessi in pietre dure*) are by Cristofano
Gaffuri (d. Florence 1626), both completed in
1600**
A single large emerald forms the well
H 37.8 cm, *W* 23.5 cm
A gift to the Emperor Karl VI (1711–40). (1542)

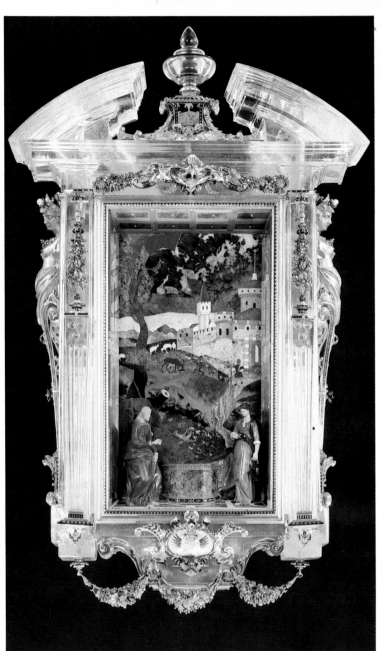

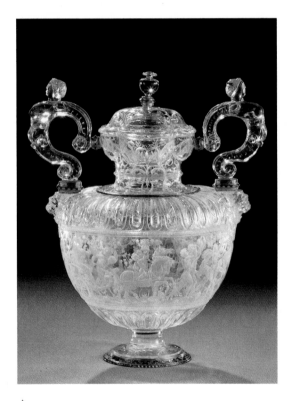

△
ROCK-CRYSTAL VASE WITH COVER
**Miseroni workshop(?), Milan, late 16th
century**
Setting enamelled gold; *H* 28.9 cm
On the bowl is the triumph of Bacchus, after
an engraving by Etienne Delaune.
From the Treasury. (2353)

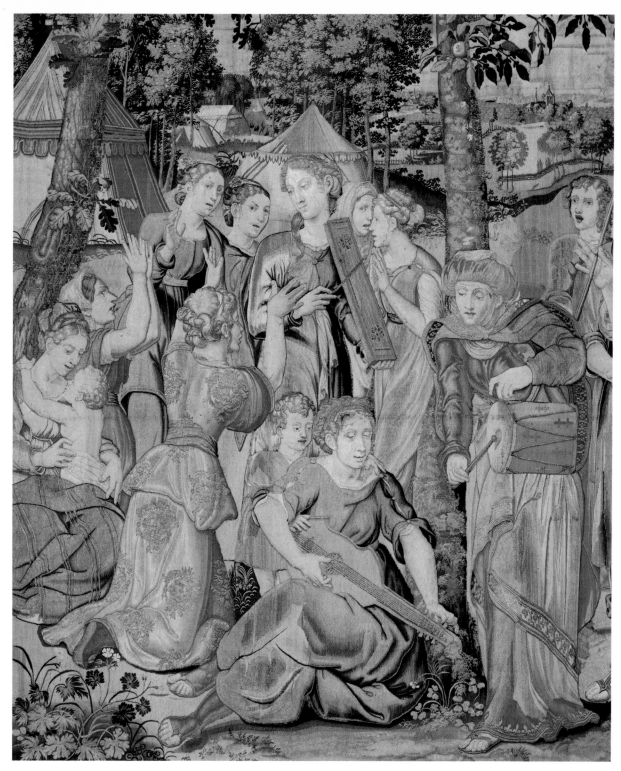

◁

THE SEVEN VIRTUES, WISDOM (SECTION)
**Woven by François Geubels, Brussels, late
16th century**
Tapestry of wool, silk, gold and silver thread;
342 × 530 cm
Next to the figure of Wisdom is Ruth, gleaning
corn.
From the old Imperial collection. (XVII/4)

△

SCENES FROM THE STORY OF MOSES: MOSES AND
ISRAEL PRAISING THE LORD (SECTION)
**Woven by Jan van Tiegen, Brussels, mid-16th
century**
Tapestry of wool, silk, gold and silver thread;
420 × 563 cm
From the old Imperial collection. (I /4)

SCENES FROM THE BOOK OF JOSHUA: JOSHUA
BEING INVITED TO ENTER THE PROMISED LAND
(SECTION)
**Brussels, _c_ 1540/50, after designs by Pieter
Coecke van Aelst**
Tapestry of wool, silk, gold and silver thread;
453 × 600 cm
From a series of eight.
From the old Imperial collection. (XIX/1)

INKSTAND
**Wenzel Jamnitzer (b. Vienna 1508,
d. Nürnberg 1585), Nürnberg, late 16th
century**
Silver; _H_ 6 cm, _L_ 22.7 cm, _W_ 10.2 cm
The animals on the sides and lid are casts from
nature.
Listed in the 1596 inventory of the Ambras
Collection. (1155–64)

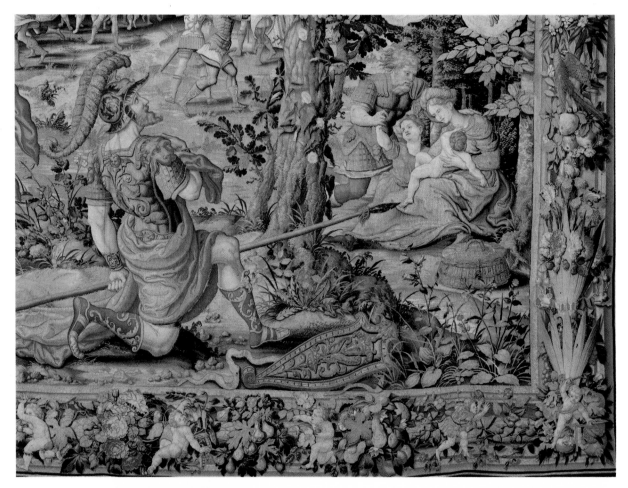

The *Kunstkammer*
of Archduke Ferdinand II
and Emperor Rudolf II

In the second half of the sixteenth century and around 1600 respectively, two main sources of the Collection of sculpture and decorative arts became evident: the *Kunstkammer* of Archduke Ferdinand II of Tirol and of Emperor Rudolf II. Objects of this provenance have already been mentioned several times, but here the two collectors and their work are described so that many objects from their collections may be understood.

Archduke Ferdinand II (p 99), born in 1529 the second son of King Ferdinand I, was Governor of Bohemia from 1547 to 1563 in Prague and thereafter until his death in 1595 State Prince of Tirol and the forelands. He began collecting on a large scale in Bohemia, his special interest being armour. On the one hand, coats of mail represented for him the historical personality of their one-time owners, and on the other, he valued them as pieces which reminded him of the events at which they had been worn. They constituted an imaginary collection of heroes, which he later called his 'honourable company'. While he was in Tirol, the Archduke was gradually able to arrange his collections, which he was trying from 1570 onwards to replenish, in Ambras Castle near Innsbruck in an orderly exhibition. The Ambras Collection of portraits became famous, and indeed at the time of Ferdinand's death it included more than a thousand likenesses of Church dignitaries, members of the Hapsburg family, rulers, celebrities, saints, miracle-workers, and fools from all parts of the world. His focus on Man from a historical and genealogical point of view as the bearer of history, and with special reference to his own great House, is thus an essential feature of Ferdinand's collection. In the *Kunstkammer* a series of ancient objects was included which had belonged to his great forebears.

The *Kunstkammer*, containing eighteen large cases reaching to the ceiling, which stood back to back in the middle of the room, was installed in a long gallery. On the walls hung pictures, and from the ceiling stuffed animals and bones. Inside, the cases were painted in different colours and their contents were arranged according to material: gold and rock-crystal perhaps in the blue case, silver in the green one. This was the first display of a collection geared to the viewer.

The contents were arranged in keeping with modern encyclopedic style, and the *Kunstkammer* contained natural history specimens and artifacts divided up with as much differentiation as possible and with a balanced proportion between various spheres of collecting. Any special emphasis of the collection should be sought in the fields which are not found elsewhere, or only rarely, namely those which demonstrate Ferdinand's personal preference. These are works in coral, glass products, and elaborate turned pieces, which are partly still in Ambras, and *Handsteine* (hand-stones). When these things were acquired, or produced in the Innsbruck Court Workshops, it was not artistic criteria that were foremost, but rather rarity value,

inventive fancy, and the ingenuity and virtuosity of the works.

Hand-stones are display objects (the size of a hand) of particularly beautiful or high grade lumps of ore or miniature mountains made up of many different samples of rock from a mine, which were artistically sculpted, sometimes with mining and sometimes with Biblical scenes. The majority of all extant hand-stones come from the Ambras Collection and are to be found in Vienna. Among the objects which belong to nature as well as art are the ostrich-egg goblet (p 99), which is built up so elaborately with corals that it could hardly be held in the hand for an actual drink, and the shell lavabo (p 102). On Wenzel Jamnitzer's inkstand (p 96), the natural history specimens are cast in silver. The little box shaped like a miniature temple (p 101), in which Ferdinand kept some of his coins, is a work of art in itself.

Emperor Rudolf II (1552–1612), Ferdinand's nephew, was the most important and the most passionate collector of the House of Austria (p 105). He spent his most decisive formative years, that is to say from eleven to nineteen, in Spain at the Court of his uncle, King Philip II. In the midst of the rich art collections, the splendour, and the ceremonial of this Court, he not only formed his taste in artistic matters, but also developed an awareness of his outstanding personal significance as a future ruler. When he became Emperor at the age of twenty-four on the death of his father, Maximilian II, in 1576, consciousness of his rank and high standards of quality were so strongly combined in his collecting activity that the priceless treasures he brought together in his Prague residence—pictures, antiques, show weapons, and the *Kunstkammer*—should all be understood as an expression of a highly sophisticated Imperial idea. His agents travelled all over Europe, acquiring works of art for him. Rudolf tried, however, to make his collections particularly exclusive by setting up extensive Court workshops. International painters, sculptors, goldsmiths, gem-carvers, graphic artists, clockmakers, and others were summoned to Prague to work, as far as possible, exclusively for the Emperor. Rudolf's cultivated artistic taste had such a strong influence on these Court artists that it is possible to speak of a Rudolfian style in art around 1600.

Very few people were favoured with permission to view the fabulous collections. The Emperor, who was introvert by nature, was obviously becoming a prey to melancholy and suffered increasingly frequent deep depressions. As he also had recourse to all kinds of alchemistic, astrological, and magic practices, which at the time were regarded as an extension of knowledge by other means, and also seldom showed himself in public, he and his treasures were shrouded in legend even during his lifetime. While the Ambras Collection has survived the centuries relatively well, unfavourable events have resulted in Rudolf's collection coming down to us in a very incomplete state.

Rudolf II was also strongly attracted to the reproduction of time by mechanical means. Through the elaborate clocks, with their manifold indexes and dials, and with astrolabes and calendars, he drew the powers of the heavens into his world and felt akin to them. Great attention was thus concentrated on the artistic fashioning of clocks (pp 112, 113). Significant technical and scientific innovations were also carried out successfully by the inventor of the pendulum clock, Christoph Margraf (p 112) and the famous mathematician and designer Jost Bürgi (p 113), whom Johannes Kepler called a second Archimedes. The sixteenth-century conception of art with its high regard for the artificial, accounts for the mechanical, clockwork products (pp 102, 114), which gave the impression of being able to invest the inanimate with life.

Sculpture at the time was under the influence of Giambologna, whose works Rudolf avidly collected (p 88). Adriaen de Vries, the most important disciple of Giambologna, was taken by Rudolf into his service. The Emperor commissioned him to sculpt his bronze bust after the Charles V portrait by Leoni (pp 105, 85) in order to measure himself directly against this great model. Along with de Vries, Hubert Gerhard was the leading sculptor in Germany. The bronze group 'Mars, Venus, and Cupid' (p 107) is a reduction of the larger than life-size group in the Castle of Kirchheim near Augsburg which he made for Hans Fugger. Johann Gregor van der Schardt (p 106) was also under the spell of Giambologna. The ivory engraver Nikolaus Pfaff, who made an exquisite little Venus (p 107), is mentioned only in the inventory of Rudolf's *Kunstkammer*.

In the field of goldsmiths' art, the Collection is indebted to the Emperor for works, again of the highest quality. The Augsburg and Nürnberg masters who were occasionally summoned to Prague adapted themselves totally to the Imperial style. Rudolf's influence is most apparent in the complicated sequence of Christoph Jamnitzer's magnificent pieces (p 108), which in addition to the *trionfi* after Petrarch also include the ages of the world, the continents, and other allegorical figures and mythological scenes. The basin of the Augsburg artist Christoph Lencker (p 109) also follows the Prague Court art in the style of its figures. A special part is played by the natural history specimens contained in it. The extremely sumptuous mount of the narwhal goblet (p 109) can only be accounted for by the unusual powers which were ascribed to the narwhal tusk. Bezoars, stomach stones from various ruminants, were valued by the Emperor on account of their alleged healing powers and their protective action against poison (pp 86, 110). The rhinoceros horn goblet, with the tusks of a wild boar worked into the cover (p 110), was supposed to increase physical strength. The Seychelles nut, on the other hand, was a clear sign that rarity was the motive for the purchase of Anton Schweinberger's lavish artistic workmanship (p 110). Rudolf II was particularly fond of precious stones, believing in the age-old powers of healing and miracle-working that were attributed to them. With the appointment of the Milan gem-carver, Ottavio Miseroni, he founded the famous Prague gem-carving studio, in which not only vessels (p 111) but also cameos (p 115) were produced. The brothers Giovanni and Cosimo Castrucci also spent long years in Prague making a valuable series of *commessi* in *pietre dure* (p 105) for the Emperor, many of which are still preserved in Vienna.

▷

WAX PORTRAIT OF ARCHDUKE FERDINAND II
(1529–95)
Francesco Segala (working mainly in Padua and Venice, second half 16th century), Innsbruck *c* 1575
Coloured wax studded with small gems and pearls; signed; 22.3 × 19.9 cm
Archduke Ferdinand, Governor of Bohemia from 1547–63, sovereign of the Tirol from 1563–95, established a famous *Kunstkammer* in Ambras Castle near Innsbruck.
Listed in the 1596 inventory of the Ambras Collection. (3085)

▽

GOBLET WITH COVER

Antonio Montano (worked in Hall, the Tirol, 1572–90), Hall, after 1582

Yellowish glass; *H* 34.1 cm

On the cup (*Kuppa*) are the coats of arms of Archduke Ferdinand II and his second Duchess Anna Katarina of Mantua.

From the Ambras Collection. (3363)

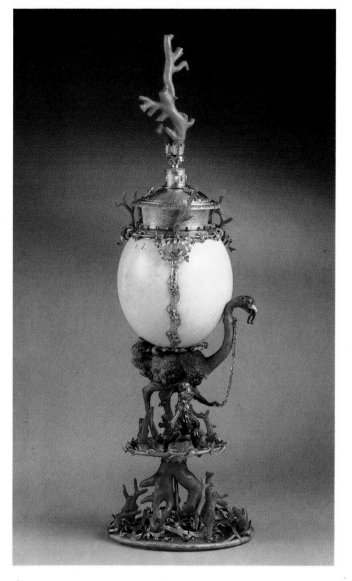

△

OSTRICH-EGG GOBLET

Clement Kicklinger (master 1561, d. Augsburg 1617), Augsburg *c* 1570/5

Ostrich egg, corals; silver-gilt or painted; *H* 56.8 cm

Behind the arrangement of the natural specimens one can sense the belief in their special magical powers.

From the Ambras Collection. (897)

▷

LEDA AND THE SWAN
**Francesco Segala (mainly working in Padua
and Venice, second half of 16th century),
Innsbruck, c 1575**
Coloured wax; painted background;
14.8 × 13.8 cm
Listed in the 1596 inventory of the Ambras
Collection. (3067)

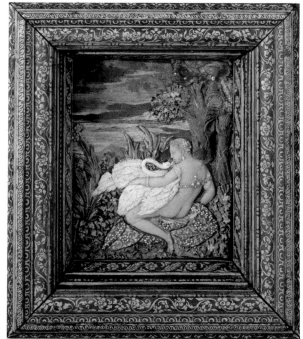

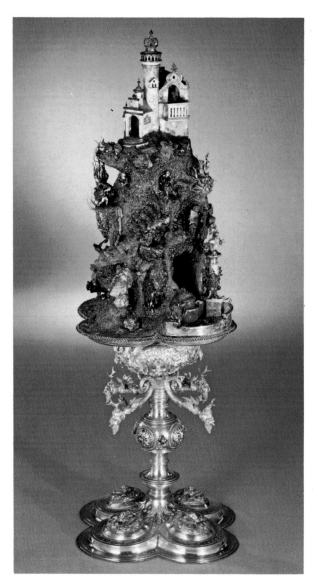

HAND-STONE IN THE FORM OF A TABLE FOUNTAIN
Bohemia(?), late 16th century
Various stone samples, enamel figurines,
silver painted, especially gilt; H 60.5 cm
King David looking down from the balcony of
his palace at Bathsheba in the bath. Miners
working on the slopes.
Listed in the 1596 inventory of the Ambras
Collection. (4161)

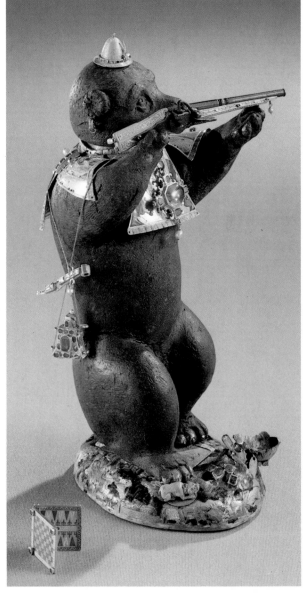

Bohemia (Joachimsthal?), mid 16th century
Stone samples, silver filigree, the figures made
of silver-glance, the buildings painted in silver;
stand silver-gilt, inlay of gold glass; *H* 27.8 cm
Scenes: The Resurrection, the three women at
the tomb of Christ, the Disciples in Emmaus
(*reverse side*).
Listed in the 1596 inventory of the Ambras
Collection. (4147)

Augsburg, second half of 16th century
Ebony, gilt bronze figurines, precious stones,
pearls; *H* 86 cm
On top is a circular temple, dedicated to the
Muses. Inside are six sections with sixty-six
slots for coins.
Listed in the 1596 inventory of the Ambras
Collection. (3390)

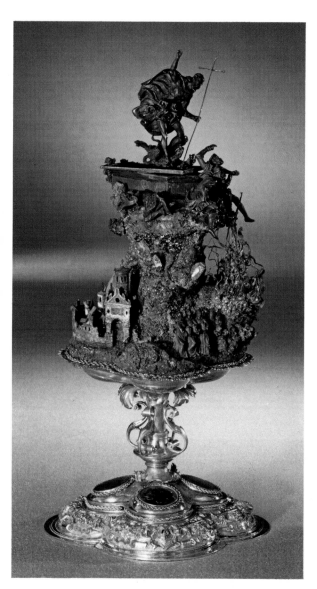

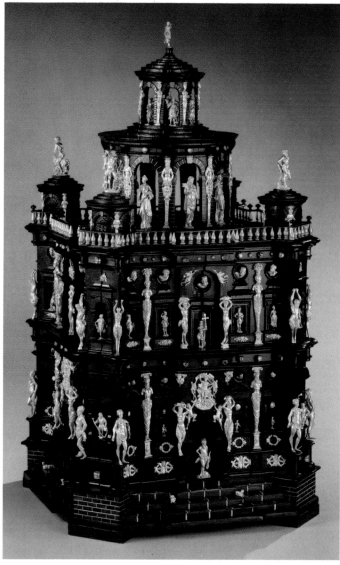

◁

THE BEAR AS HUNTER
**Gregor Bair (b. Meran, master 1573,
d. Augsburg 1604), Augsburg, *c* 1580/90**
Bear silver, covered with musquash; base
enamelled silver, gold, precious stones, pearls;
H 21.3 cm
Allegory of a topsy-turvy world.
Listed in the 1596 inventory of the Ambras
Collection. (1094)

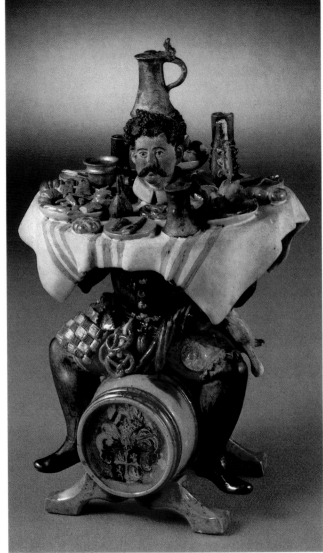

▷

HUMOROUS BOTTLE

Christoph Gantner (d. Innsbruck 1605),
Innsbruck *c* 1580/90

Tin-glazed earthenware; *H* 26.6 cm
The head of the figure can be removed. The
glutton cannot reach the near-by delicacies as
his arms have to support the richly laid table—
a punishment for his gluttony.
Listed in the 1621 inventory of the Ambras
Collection. (3155)

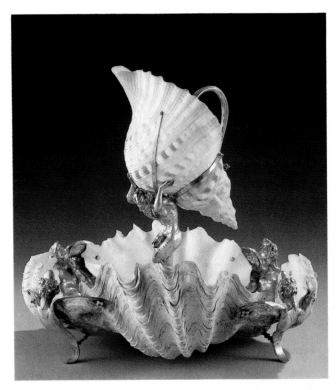

△

SHELL LAVABO: EWER AND BASIN

Elias Gross (master *c* 1566, d. 1572 in
Augsburg), Augsburg, *c* 1570

Tricnada shells, triton shell, silver-gilt; *H* of
ewer 32 cm, *W* of basin 39.5 cm
From the Ambras Collection. (4128 and 4129)

▷

GIRL PLAYING A CITTERN: MECHANICAL DOLL

Spain(?), second half of 16th century

Iron works; player's body painted wood;
garments linen and silk brocade; *H* 44 cm
The doll moves with mincing steps, turns its
head and strikes the strings of the instrument.
Such human figures were greatly admired, as
they gave the illusion of the inanimate brought
to life.
Koloman von Wischnitz-Naszod Bequest,
1934. (10,000)

TABLE CLOCK

**Jeremias Metzker (worked in Augsburg
between 1555 and 1599), Augsburg 1564,
signed and dated**

Gilt bronze; iron works; *H* 29.7 cm
Face with hour-dial numbered I–XII and 1–24,
sections for length of day and night or sunrise
and sunset respectively, calendar dial (*left*),
position of the sun in the zodiac (*right*), small
dial indicating the Sundays, dial to regulate
the striking mechanism (*above right*); on the
narrow sides control dials; on the second face a
mechanical Astrolabe, weekday indicator.
From the Treasury. (852)

ARMILLARY SPHERE

**Pierre de Fobis (worked in Lyons between
1507 and *c* 1575), Lyons, mid-16th century,
signed**

Gilt brass, iron, glass; *H* 53 cm
The armillary sphere served to show the
different celestial movements and is thus a
precursor of the orreries.
Presented in 1949 by Claire de Rothschild in
memory of Dr Alphonse de Rothschild. (9843)

Above: Cross pendant
South German, early 17th century
Enamelled gold; 13 diamonds, 6 rubies,
2 pendant pearls; *H* 6.1 cm
Gustav Benda bequest, 1932. (9022)

Centre left: Medallion: St John the Evangelist
Milan, late 16th century
Enamelled gold; *H* 5.6 cm
Listed in the 1619 Estate inventory of the
Emperor Matthias. (1608)

Centre: Pendant: Moses smiting the rock
Augsburg, *c* 1600
Enamelled gold; 11 diamonds, 4 rubies,
3 pendant pearls; *H* 7.3 cm
From the Treasury. (1616)

Centre right: Medallion: Judith with the head of
Holofernes
Milan, late 16th century
Enamelled gold; *H* 4.8 cm
The setting is missing.
Listed in the 1619 Estate inventory of the
Emperor Matthias. (1586)

Below: Pendant, huge pearl in the form of a
cluster of grapes
South German, early 17th century
Setting: enamelled gold, rubies; *L* 5.3 cm
Listed in the 1750 Treasury inventory. (2127)

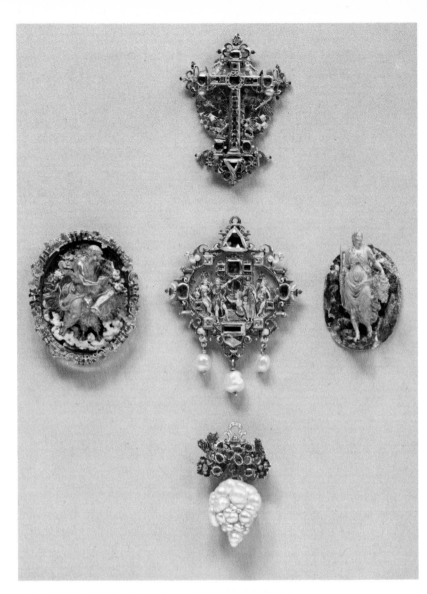

MINIATURE ALTAR: ADORATION OF THE MAGI
**Court Workshop, Munich or Augsburg,
c 1600**
Ebony; enamelled gold; pearls, diamonds,
emeralds, rubies, sapphires; 17.5 × 11.9 cm
Present from the Empress Eleonora Magdalena
Theresia to the Emperor Leopold I (reigned
1658–1705, married Eleonora 1676) on the
occasion of his name-day. (3218)

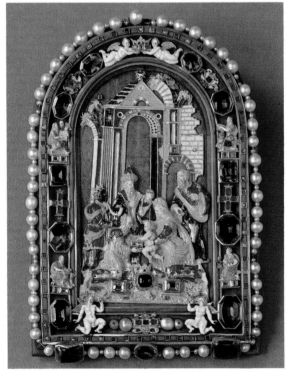

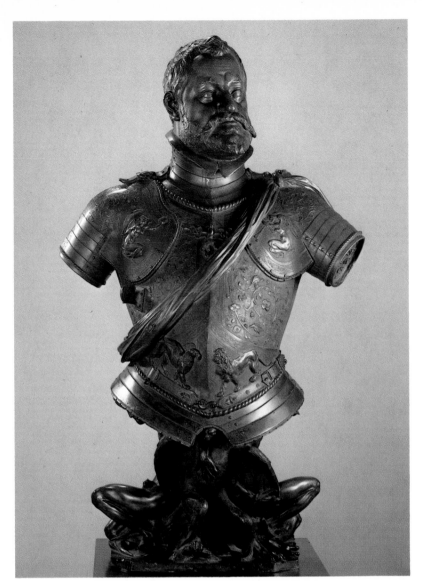

BUST OF THE EMPEROR RUDOLF II
Adriaen de Vries (b. The Hague c 1545, d. Prague 1626), Prague, 1603, signed and dated
Bronze, light brown lacquer; *H* 112 cm
Conceived as a companion piece to the bust of Emperor Karl v by Leone Leoni.
Listed in the inventory of the *Kunstkammer* of Emperor Rudolf II, carried off to Sweden in 1648, brought back in 1806. (5506)

▽

VIEW OF THE HRADSCHIN IN PRAGUE
Castrucci Court Workshop, Prague (Giovanni and Cosimo Castrucci, worked in Florence and Prague), early 17th century
Commesso in *pietre dure;* 23.5 × 11.4 cm
After a woodcut by Johann Willenberger.
From the Treasury. (3060)

MERCURY

**Johann Gregor von der Schardt (b. Nimeguen
c 1530, worked mainly in Nürnberg),
Nürnberg, late 16th century**
Bronze, brown lacquer; *H* 53 cm
From the Treasury. (5900)

ALLEGORY OF SPRING

**Wenzel Jamnitzer (b. Vienna 1508,
d. Nürnberg 1585), and Johann Gregor von
der Schardt, Nürnberg c 1580**
Gilt cast brass; *H* 71.2 cm
The figures of the four seasons were the
bearers of a precious silver fountain.
Listed in the 1607/11 inventory of the
Kunstkammer of the Emperor Rudolf II. (1118)

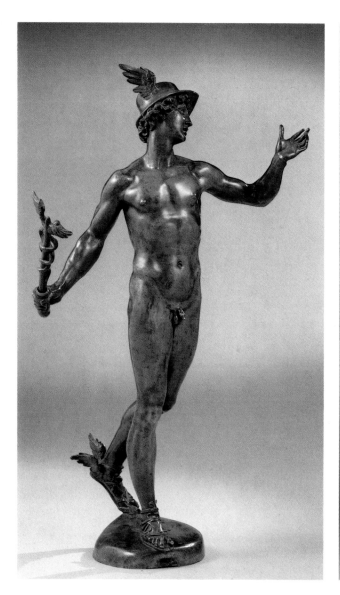

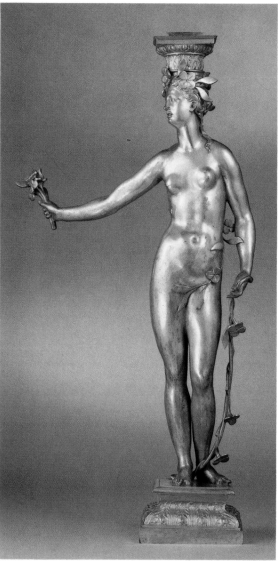

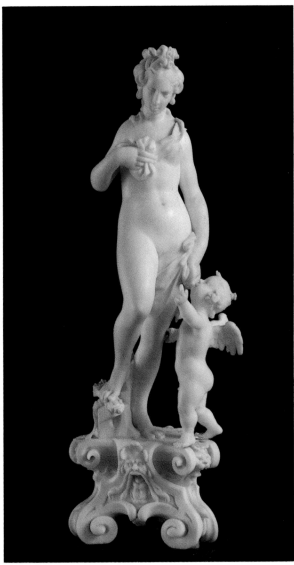

VENUS AND CUPID

Nikolaus Pfaff, Prague, *c* **1600**

Ivory; *H* without base 13.5 cm
No biographical details are known for Pfaff.
Listed in the 1607/11 inventory of the
Kunstkammer of the Emperor Rudolf II as a
work by N. Pfaff. (4658)

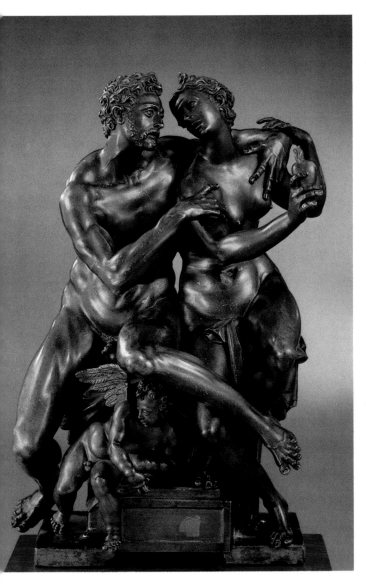

MARS, VENUS, AND CUPID

Hubert Gerhard (b. Amsterdam(?) *c* **1550,
d. Munich 1622/3), late 16th century**

Bronze, reddish-brown lacquer; *H* 41.4 cm
The intricate intertwining of the figures
identifies them as works of the school of
Giambologna.
From the Treasury. (5848)

107

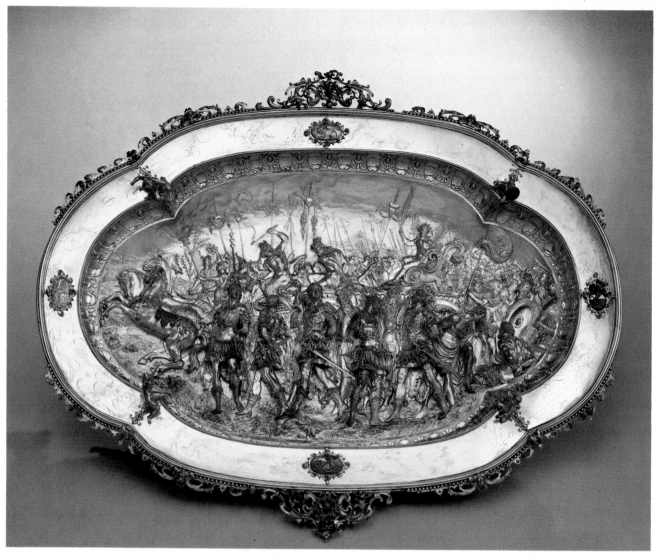

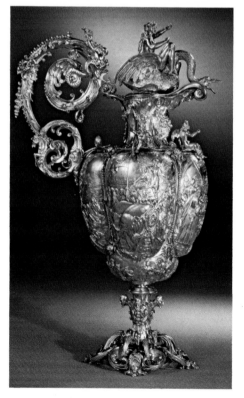

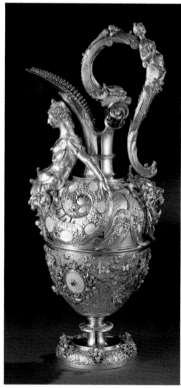

▷

ORNAMENTAL EWER

Christoph Jamnitzer (b. and d. Nürnberg 1562–1618), Nürnberg between 1603 and 1607

Silver-gilt, enamel; *H* 43.5 cm

The panels of the ewer are chased with five *trionfi* after Petrarch: the Triumph of Chastity over Love; of Death over Chastity; of Fame over Death; of Time over Fame; of Eternity over Time.

From the Treasury. (1128)

▷▷

EWER

Nikolaus Schmidt (b. Greifswald, master 1582, d. Nürnberg 1609), Nürnberg, *c* 1600

Silver-gilt, mother of pearl, garnets; *H* 54 cm

It is known that a basin belongs to this ewer, which can be identified in the 1607/11 inventory of the *Kunstkammer* of the Emperor Rudolf II.

From the Treasury. (1124)

ORNAMENTAL DISH DEPICTING THE STORY OF EUROPA
**Christoph Lencker (b. Ludwigsorget c 1556,
d. Augsburg 1613), Augsburg, late 16th
century**
Silver-gilt, enamel; *L* 69 cm, *W* 58.5 cm
Listed in the 1607/11 inventory of the
Kunstkammer of the Emperor Rudolf II. (1110)

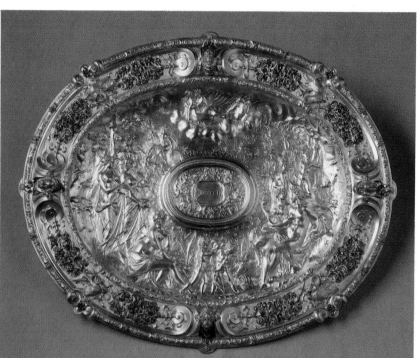

◁
ORNAMENTAL DISH DEPICTING CUPID'S
TRIUMPHAL PROCESSION
**Christoph Jamnitzer (b. and d. Nürnberg
1563–1618), Nürnberg between 1603 and
1607, signed**
Silver-gilt, enamel; *L* 64.7 cm, *W* 53 cm
Together with the ewer (1128), the basin
forms a set which is considered the most
important work of the master.
Listed in the 1607/11 inventory of the
Kunstkammer of the Emperor Rudolf II. (1104)

▷
GOBLET WITH COVER, MADE OF NARWHAL
TUSK IVORY
Prague Court Workshop, early 17th century
Mount: enamelled gold, diamonds, rubies; the
cover is crowned with two cameos of agate;
H 22.2 cm
The tusk of the Narwhal was supposed to be
the horn of the legendary Unicorn. It is for this
reason that extraordinary magical powers are
ascribed to it.
Listed in the 1619 Estate inventory of the
Emperor Matthias. (1113)

▷ ▷
JASPER JUG
Miseroni Workshop, Milan, late 16th century
Gold mounts by Paulus van Vianen
(b. Utrecht after 1570, d. Prague 1613),
Prague 1608, signed and dated
H 35.9 cm
Listed in the 1607/11 inventory of the
Kunstkammer of the Emperor Rudolf II. (1866)

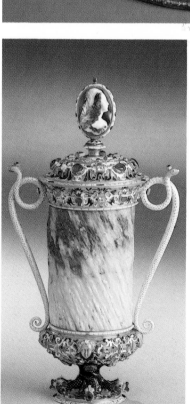

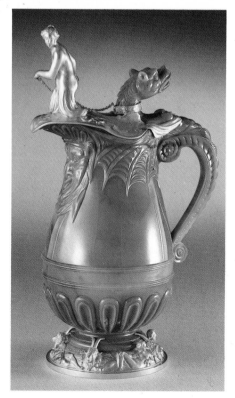

GOBLET WITH COVER
By Nürnberg or Augsburg masters (working) in Prague, 1611
Rhinoceros horn, tusk of a young boar, silver-gilt; *H* 49.7 cm
These natural specimens, which were ranked as trophies, were valued as much for their rarity as the magical powers ascribed to them. Listed in the 1607/11 inventory of the *Kunstkammer* of the Emperor Rudolf II. (3709)

BOWL WITH COVER MADE FROM A HOLLOWED-OUT BEZOAR
Prague, Imperial Court Workshop, early 17th century
Mount: enamelled gold; *H* 14.3 cm
Rudolf II valued the magical powers of bezoars particularly highly. He used them among other remedies against melancholy. From the Treasury. (3259)

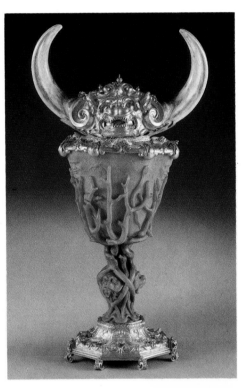

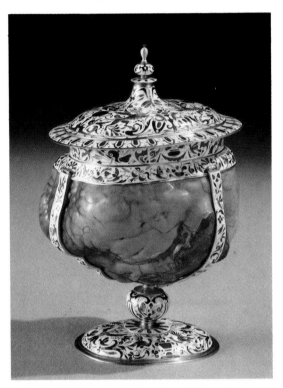

EWER MADE OF HALF A SEYCHELLES NUT
Anton Schweinberger (Augsburg master, Court Goldsmith of Emperor Rudolf II, worked in Prague 1587–1603, d. *c* 1603), Prague *c* 1600, signed
Carved Seychelles nut, silver-gilt; *H* 38.5 cm
In 16th-century Europe the nut *Lodoicea Maledivia* was considered a great rarity and a wonder of the first rank.
Listed in the 1607/11 inventory of the *Kunstkammer* of the Emperor Rudolf II. (6872)

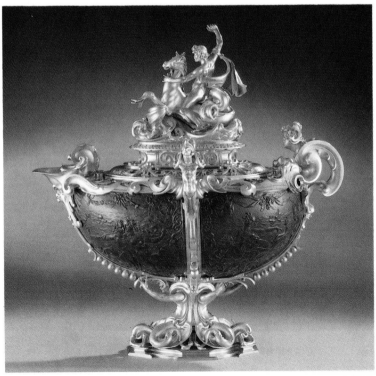

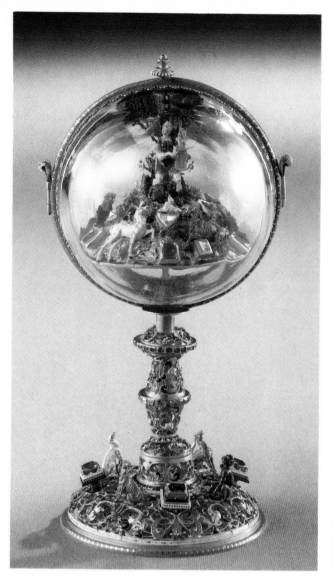

△

ORPHEUS GLOBE

South German, second half of 16th century
Rock-crystal, enamelled gold, diamonds,
rubies; *H* 16.7 cm
From the Treasury. (1097)

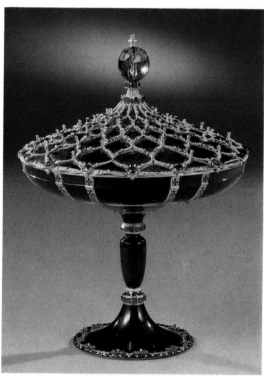

△

PRASE BOWL WITH COVER ON A TALL PEDESTAL
Prague, Imperial Court Workshop, *c* 1600
Mount: enamelled gold, garnets, citrine
(yellow quartz); *Diam* 18.4 cm, *H* 23.8 cm
Listed in the 1607/11 inventory of the
Kunstkammer of the Emperor Rudolf IIs. (1918)

◁

MOSS-AGATE BOWL

**Ottavio Miseroni (Gem-carver from Milan,
d. Prague 1624), Prague, early 17th century**
Mount: enamelled gold; *H* 17.7 cm
With the summoning of Ottavio Miseroni to
Prague in 1588, Rudolf II founded a famous
studio for gem-carving, which existed until
1684.
Listed in the 1607/11 inventory of the
Kunstkammer of the Emperor Rudolf II. (1987)

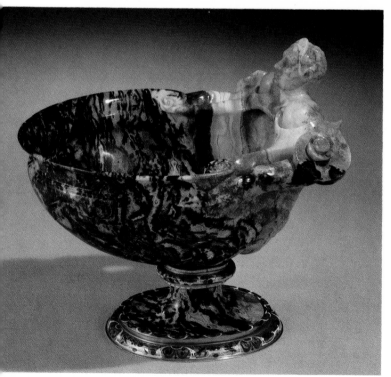

CELESTIAL GLOBE

Georg Roll (b. Liegnitz 1546, d. Augsburg 1592) and Johann Reinhold (b. Liegnitz(?) _c_ 1550, d. Augsburg 1590), Augsburg 1583/4, signed and dated

Bronze, gilt brass, partly painted, silver, wood; iron works; _H_ 54 cm

Listed in the 1607/11 inventory of the _Kunstkammer_ of the Emperor Rudolf II. (854)

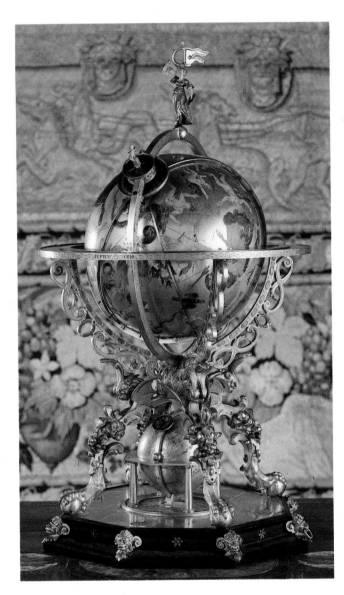

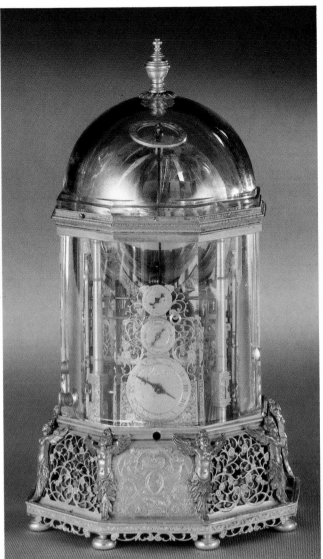

\triangleright

PENDULUM CLOCK

Christof Margraf (worked in Prague between 1587 and 1620/4), Prague, 1596, signed and dated

Wood, gilt copper, glass, silver ore, painted in body colours; iron works; _H_ when open 40.3 cm, _W_ 28 cm, _D_ 23 cm

From the Treasury. (845)

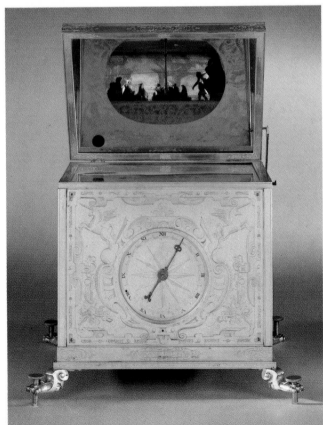

TABLE CLOCK

Jost Bürgi (b. Lichtensteig, Canton of St Gallen, Switzerland 1552, d. Kassel 1632), Prague, between 1622 and 1627, signed
Gilt brass, silver, rock-crystal; brass works; H 18.6 cm

The hour, minute, and second dials lie one on top of the other. This is one of the main works of the great mathematician and technologist, demonstrating several technical innovations. Listed in the 1750 inventory of the Treasury. (1116)

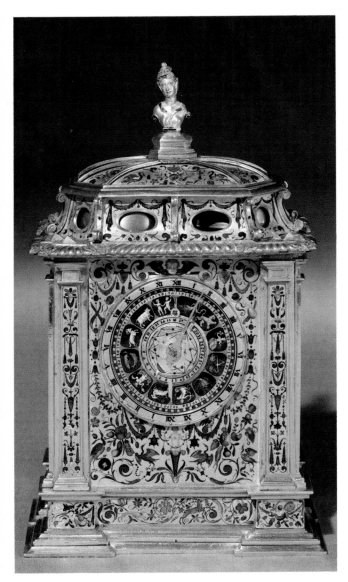

TABLE CLOCK

Case by Cornelius Gross (Master before 1534, d. Augsburg 1575), deep cut enamel by David Altenstetter (master 1573, d. Augsburg 1617), Augsburg c 1570/5
Silver, enamel; iron works and brass; H 21.8 cm
Listed in the 1607/11 inventory of the *Kunstkammer* of the Emperor Rudolf II. (1121)

PENDULUM CLOCK

Jost Bürgi (b. Lichtensteig, Canton of St Gallen, Switzerland, 1552, d. Kassel 1632), Prague c 1604
Bronze, gilt brass, painting on parchment, glass, rock-crystal; brass and iron works; H 39.3 cm
First known example with a heliocentric orrery.
From the Treasury. (846)

MUSICAL BOX IN THE FORM OF A SHIP
**Hans Schlottheim (b. Naumburg/Saale
c 1545, d. Augsburg 1625), Augsburg 1585,
dated**
Silver-gilt, figurines and sails painted; iron
works: H 67 cm, L 66 cm (874)

CLOCK WITH FIGURES REPRESENTING DIANA ON A
CENTAUR
**Augsburg, c 1600/10; goldsmith work by
Melchior Mair (b. c 1565, master c 1598, d.
Augsburg 1613)**
Silver, parcel-gilt, deep-cut enamel, precious
stones, wood; H 39.5 cm
The mechanical works are in the base, and the
works of the clock in the body of the Centaur.
Listed in the 1619 Estate inventory of the
Emperor Matthias. (1166)

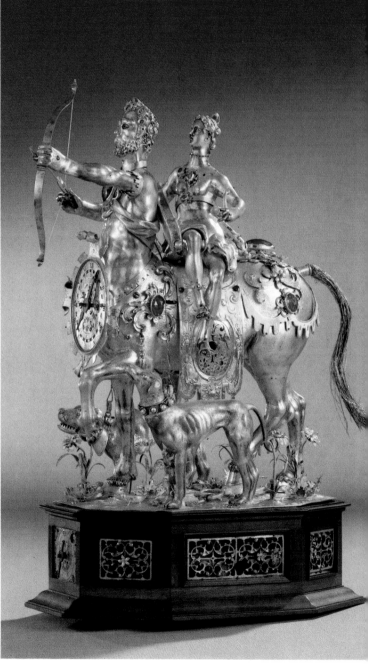

CAMEOS DATING FROM THE RUDOLFIAN PERIOD

Above left: Rudolf II
**Ottavio Miseroni (d. Prague 1624), Prague
c 1590, signed**
Chalcedony, silver filigree; Setting: enamelled
gold, Prague, c 1610/20); H 5.6 cm, W 4.1 cm
Listed in the 1750 inventory of the Treasury.
(XII/58)

Above right: Ceres
Ottavio Miseroni, Prague, c 1600
Relief *commesso* on a chalcedony ground;
Setting: enamelled gold; Prague, early 17th
century; H 8.2 cm, W 6.6 cm
Listed in the 1619 Estate inventory of the
Emperor Matthias. (XII/29)

Centre: Half-figure of a girl
Ottavio Miseroni, Prague c 1600
Relief *commesso* on a chalcedony ground;
Setting: gold, single pearl; H 8.5 cm, W 5.3 cm
Listed in the 1750 Treasury inventory.(XII/140)

Below left: Latona transforming the Lycian
peasants into frogs
**Alessandro Masnago, Milan, late 16th
century**
Jasper; Setting: enamelled gold; Milan, end of
16th century; H 6 cm, W 7.3 cm
Listed in the 1750 inventory of the Treasury.
(XII/136)

Below right: The Entombment of Christ
**Alessandro Masnago, Milan, late 16th
century**
Agate; Setting: silver-gilt; H 5.6 cm, W 7.3 cm
Listed in the 1619 Estate inventory of the
Emperor Matthias. (XII/822)

Baroque

In the Baroque period there was a shift of emphasis in collecting, before interest turned away from the *Kunstkammer* in the eighteenth century. Ousted by the sensuous charm of ivory, which now fascinated the collector, the bronze statuette lost some of its importance. Goldsmiths' art and the production of clocks and mechanical instruments had also passed their peak in Rudolf's time.

An extremely interesting and unique artist, whose identity is still unknown, is the so-called *Furienmeister*, Master of the Furies (p 117), whose works have been variously dated from the middle of the seventeenth until the second half of the eighteenth century. The language he speaks is, nevertheless, incomparably more vigorous than that used in the eighteenth century. The vibrant, sensuous surface of the similarly elongated and mannered figures of Poseidon and Amphitrite from around 1700 (p 118), which are ascribed to the Venetian Antonio Leoni, are just as far removed from him in style as Jacob Auer's gently animated modelling in the virtuoso piece 'Apollo and Daphne' (p 125). The *Furienmeister* is probably a South German artist of the early seventeenth century, who had in his field of vision both the achievements of Giambologna and also the nervous Chiliasm of German art around 1500, which he elaborated into a very personal style of gripping and expressive power. The early Baroque figures of Leonhard Kern (p 118) make an emotionless and earthbound impression compared with them, while Adam Lenckhardt's realistically solid group (p 118) reflects the coarse, boisterous manners of the time of the Thirty Years' War. A great master of ivory sculpture was Ignaz Elhafen, who knew how to draw the most delicate, sensuous charms out of the warm, dense material. He was particularly fond of using mythological scenes to represent beautiful bodies (p 122), which he divided up pleasingly in his reliefs in a composition of parallel pictures. In sharp contrast to him is another large-scale sculptor, Johann Ignaz Bendl, who allows his graphic reliefs to culminate in vehemently animated groups in the foreground, beyond which the setting acquires greater depth. The Vienna collection has a twelve-piece series of these (p 122). The three great equestrian statues of Matthias Steinl, of which Emperor Joseph I is reproduced here (p 125), occupy a special position. In this technical work of art, made up of sections, a meticulous realism in detail is combined with the huge animated conception of the young future Emperor as the conqueror of the snake-headed spirit of evil. Another work attributed to Steinl is the towering, many-faceted 'Allegory of Water and Air' (p 125), which clearly competes with Giambologna's 'Rape' group and which in so doing admirably demonstrates technical composition by following the curved shape of the tusk.

In the seventeenth century many princes followed the fashion of producing complicated turned pieces in ivory. Nürnberg had acquired a special reputation in this field. The leading master was Lorenz Zick, who instructed the Emperor Ferdinand III in this technique in Vienna, and whose father, Peter Zick, was the master of Emperor Rudolf II. The trick with the 'Counterfeit globe' (p 117) consisted in turning the globe out of a single piece of ivory and through small openings in the globe, two medallions for miniatures. Zick had great skill in constantly inventing new technical surprises, which had many imitators. Along with the ivories, vessels of precious stones formed the biggest addition to the Vienna Treasury in the seventeenth century. Dionysio Miseroni, the son of Ottavio, worked almost exclusively for the Emperor in Prague. He developed heavy, angular shapes for vessels, whose decoration ranges from severe surface ribbing to Italianate tendril patterns (p 119). Along with these, pieces from Milan found their way—mostly as presents—to the Court at Vienna (pp 119, 120).

The few Baroque works of goldsmiths' art in the Collection are not really *Kunstkammer* pieces, but decorative works that had fallen out of use and had been handed over to the Treasury by the Court. The heavy gold breakfast service belonging to Maria Theresa and made by Anton Matthias Domanek (p 127), which along with the matching toilet-set of her husband, Franz Stephan of Lorraine, consists of some seventy pieces, is one of the main works of the Vienna goldsmiths' art of the eighteenth century.

Portrait sculptures found their way into the Collection more or less by chance (pp 124, 125, 127). Giulia Albani (p 125) was the aunt of Pope Clement XI, and had brought him up after the early death of his mother. He had a memorial erected on her tomb in San Domenico in Pesaro, which occasioned Rusconi's sculpture, showing her in eternal devotion.

ONE OF THE FURIES
South German, early 17th century
Ivory; *H* 37.4 cm
A group of expressively shaped ivory figures
attributed to an anonymous master. These
statuettes earned him the title *Furienmeister*
(the master who created the Furies).
Transferred 1846 from the Natural Philosophy
Room. (3727)

ONE OF THE HESPERIDES FEEDING THE DRAGON
LADON WITH GOLDEN APPLES
Furienmeister, **South German, early 17th
century**
Ivory; *H* 30.4 cm
Transferred 1846 from the Natural Philosophy
Room. (4559)

◁

TURNED IVORY PIECES
Left: the so-called *Konterfetten* globe (globe with
miniatures)
**Lorenz Zick (b. and d. Nürnberg 1594–1666)
Nürnberg, between 1637 and 1657**
H 37.5 cm
On the globe are shell cameos depicting the
Hapsburg Emperors from Emperor Rudolf II
to Emperor Ferdinand III.
Centre: Goblet with cover crowned with
flowers.
South German, early 17th century
H 54 cm
Right: Goblet with cover
**Georg Burrer (worked in Stuttgart, early 17th
century), Stuttgart, 1616, signed and dated**
H 37.4 cm
All three pieces from the Treasury. (4503,
4777 and 4681)

POSEIDON AND AMPHITRITE
Italian, *c* 1700, in the style of Antonio Leoni
Ivory; *H each* 29 cm
Bought in 1931 on the art-market. (8798 and 8799)

SATYR WITH THE NYMPH CORISCA
Adam Lenckhardt (b. Würzberg 1610, d. Vienna 1661), Vienna, 1639, signed and dated
Ivory: *H* without base 22.7 cm
From the Treasury. (4564)

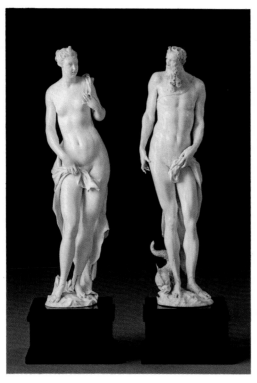

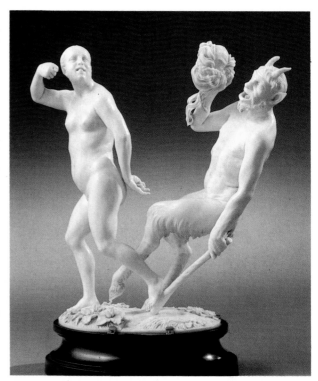

▷
ABRAHAM AND KING DAVID
Leonhard Kern (b. Forchtenberg, Württemberg 1585, d. Schwäbisch Hall 1662), Schwäbisch Hall, *c* 1620 and c 1625 respectively
Ivory; *H* 30 cm and 27.4 cm
From the Treasury. (4571 and 4573)

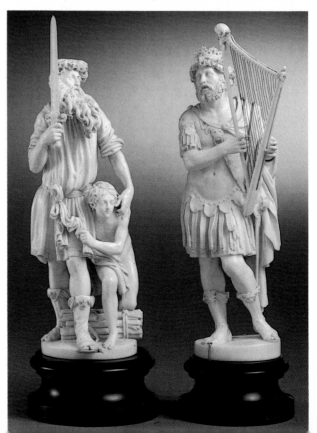

ORNAMENTAL ROCK-CRYSTAL VASE

Milan, first half of 17th century

Base silver-gilt, tendril in relief of enamelled gold; H 54.4 cm

Hunting scenes are engraved on the bowl of the vase.

From the Treasury. (1549)

CITRINE FLOWER VASE

Dionysio Miseroni (b. and d. Prague c 1607–61), Prague, 1647/8

H without flowers 26 cm

The flowers are made of coloured agates and jaspers, of chalcedony and rock-crystal; stand enamelled gold.

·Transferred to the Vienna Treasury in 1648. (1330)

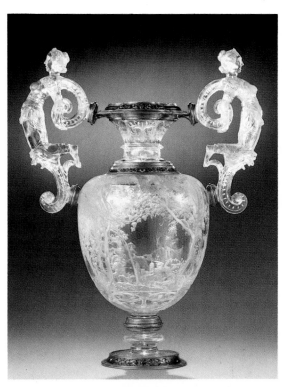

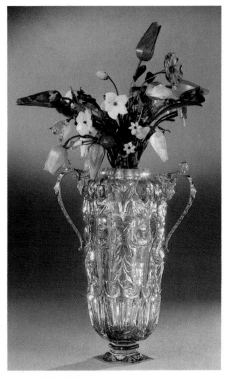

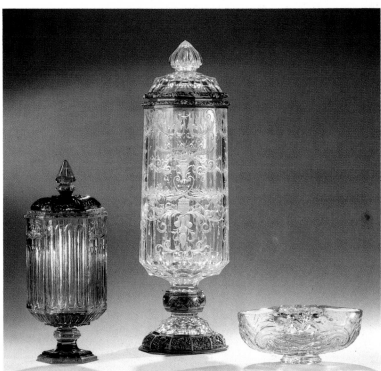

THREE ORNAMENTAL VESSELS

Dionysio Miseroni (b. and d. Prague c 1607–61)

Large faceted vase with cover, with tendril intaglio

Prague, 1653–5

Rock-crystal; mount silver-gilt, enamel; H 47.2 cm

Hexagonal goblet with cover

Prague 1648/9

Smoked quartz; base silver-gilt; basse-taille enamel; H 29 cm

Bowl of light smoked quartz

Prague, 1650

L 18.5 cm

All three pieces were transferred direct to the Vienna Treasury. (2246, 1339 and 1367)

BRATINA: RUSSIAN BROTHERHOOD CUP
Moscow, c 1630/40
Gold, part-enamelled; rubies, sapphires,
emeralds, pearls; H 27 cm
On the cover the white Polish Eagle is depicted
with the letters WR on the breast. Russian
inscription. Present from Archduke Michael
Feodorovish of Moscow to King Wladislaus IV
of Poland in 1637.
Listed in the 1750 inventory of the Treasury.
(1114)

CENTREPIECE IN THE SHAPE OF A DRAGON WITH A
LION'S HEAD
Milan, c 1650
Rock-crystal; base silver-gilt, tendril in relief
enamelled gold; H 48.2 cm. L 56.4 cm
Listed in the Vienna Treasury in 1659. (2331)

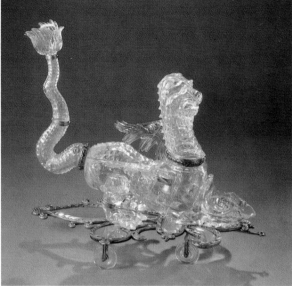

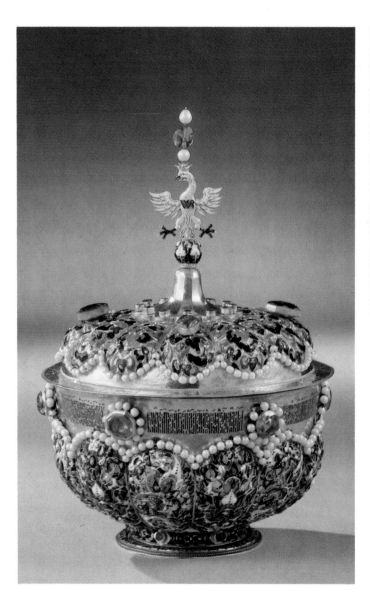

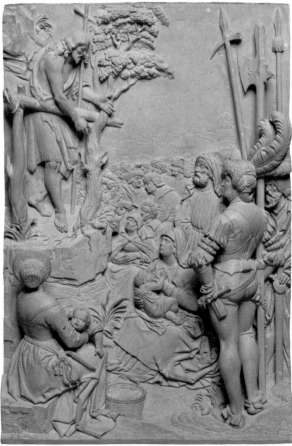

▷

THE SERMON OF JOHN THE BAPTIST
**Georg Schweigger (b. and d. Nürnberg
1613–90), Nürnberg, 1645, signed and dated**
Kehlheim stone; 20 × 14 cm
To the left of the soldier with the plumed
helmet is Albrecht Dürer.
From the Ambras Collection. (4376)

△

KING LOUIS XIII OF FRANCE'S RIDING LESSON:
BALLOTADE POSITION

**Brussels, *c* 1660, studio of Everard Leyniers
(1597–1670), with initials**

Wool and silk tapestry, some gold and silver
thread; 410 × 382 cm

From a series of eight.

Purchased on the occasion of the Emperor
Leopold I's wedding in 1666. (XL/7)

◁

FIGHT WITH THE DRAGON

**Daniel Neuberger (b. Augsburg *c* 1625,
d. Regensburg 1680), Vienna, between 1651
and 1663**

Wax relief; 14 × 15.8 cm

From the Ambras Collection. (3087)

▷

SCENES FROM THE LIFE OF ALEXANDER THE GREAT:
BATTLE OF THE GRANICUS, ALEXANDER ON
HORSEBACK IN THE THICK OF THE BATTLE (SECTION)
**Paris Gobelins (State Tapestry Factory) 1687/8,
Jan Jans the Younger, with initials**
Wool and silk tapestry, some gold and silver
thread; 485 × 845 cm
From a series of eleven, after paintings by
Charles Le Brun (1619–90).
From the Estate of the Emperor Franz I of
Lorraine. (v/2)

THE JUDGMENT OF PARIS
**Ignaz Elhafen (b. Innsbruck 1658,
d. Düsseldorf 1715), Vienna, c 1695/1700,
with initials**
Ivory; 10.4 × 16.7 cm
From the Treasury. (4178)

THE BATTLE OF THE AMAZONS
**Ignaz Elhafen (b. Innsbruck 1658,
d. Düsseldorf 1715). Vienna(?), c 1680/5**
Light cedar wood; 12.8 × 19.7 cm
From the Ambras Collection. (3932)

PHAETON SCORCHING THE EARTH
**Johann Ignaz Bendl (worked in Bohemia and
Vienna, c 1730), Vienna, 1684**
Ivory; 14 × 23.8 cm
From the Treasury. (3782)

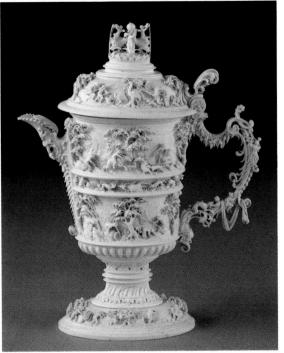

TANKARD WITH BACCHANALIAN SCENES
(German or Netherlandish artist, working in Vienna(?) from before 1662 until after 1680), Vienna(?), 1662, with initials BG and dated
Ivory; H 27.6 cm
Listed in the 1750 inventory of the Treasury.
(4499)

TANKARD WITH LID DEPICTING HUNTING AND FISHING SCENES
Initials BG (German or Netherlandish artist, working in Vienna(?) before 1662 until after 1680), Vienna(?), late 17th century
Ivory; H 29.8 cm
Listed in the 1750 inventory of the Treasury.
(4472)

Paul Strudel (b. Cles(?), the Tirol, 1648, d. Vienna 1708), Vienna, 1695
Marble from Laas; *H* 86 cm
Purchased 1832 at auction. (5458)

▷
Jakob Auer(?), (b. Haiming, the Tirol, 1646, d. Grins/Landeck 1706), Vienna, late 17th century
Ivory: *H* 43.9 cm
From the Treasury. (4537)

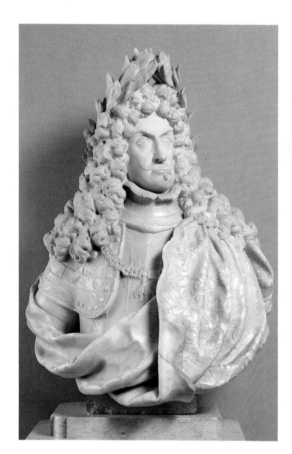

TUNISIAN CAMPAIGN OF THE EMPEROR KARL V:
BATTLE IN THE RUINS OF CARTHAGE (SECTION)
Studio Jodocus de Vos, Brussels, between 1712 and 1721, signed; cartoons by Jan Cornelisz Vermeyen (1490/5–1559), painted from 1546 onwards
Wool and silk tapestry, gold and silver thread;
520 × 860 cm
From a series of ten.
Woven for the Emperor Karl VI (reigned 1711–40). (x/9)

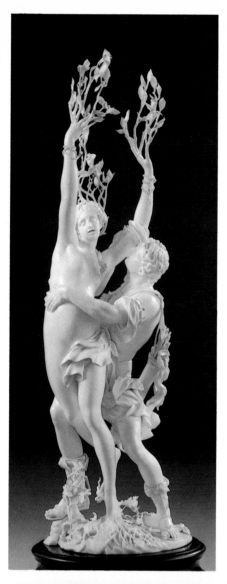

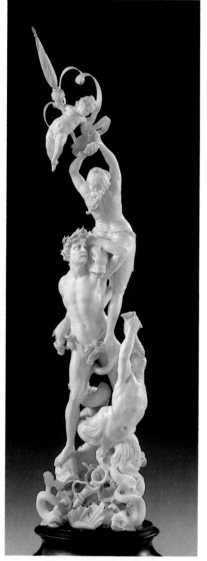

ALLEGORY OF THE ELEMENTS WATER AND AIR
Matthias Steinl(?) (b. _c_ 1644, d. Vienna 1727), Vienna _c_ 1700
Walrus tusk; _H_ 43.9 cm
From the Treasury. (4533)

PORTRAIT BUST OF GIULIA ALBANI DEGLI ABATI OLIVIERI (1630–1718)
Camillo Rusconi (b. Milan 1658, d. Rome 1728), Rome, 1719
Marble; _H_ 96 cm
Originally part of a tombstone in San Domenico in Pesaro.
Taken over from the Austrian Museum of Applied Arts in 1940. (9914)

THE EMPEROR JOSEPH I ON HORSEBACK
Matthias Steinl (b. _c_ 1644, d. Vienna 1727), Vienna, 1693, signed and dated
Ivory; _H_ including base 70.8 cm
From the Treasury. (4663)

△

THE VICTORIES OF DUKE KARL V OF LORRAINE
(1643–90): THE BATTLE OF BRATISLAVA 1683
(SECTION)
**Ducal Tapestry Factory, Nancy; weaver
Charles Mite, between 1709 and 1718; after
cartoons or oil paintings by Jean Louis Guyon
(1672–1736), Jean Baptiste Martin (1659–
1735) and Claude Jacquard (1685–1736)**
Wool and silk tapestry; 470 × 630 cm
From a series originally comprising nineteen
pieces. From the Estate of the Emperor Franz I
of Lorraine (d. 1765). (IX/1)

▷

TABLE DECORATION BELONGING TO PRINCE KARL
OF LORRAINE (BROTHER OF THE EMPEROR FRANZ I)
**Petrus Josephus Fonson (worked in Brussels
in the second half of 18th century), Brussels,
1755, signed and dated**
Gold, silver, and gilt brass, porcelain;
L 63.2 cm W 46 cm
Presented to the Treasury in 1765. (1268–1280)

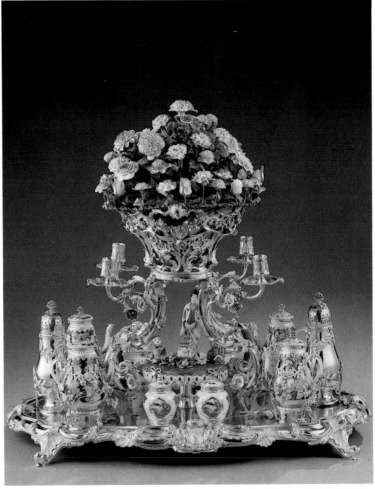

▷

PORTRAIT BUST OF THE ARCHDUCHESS MARIE
ANTOINETTE
**Jean Baptiste Lemoyne (b. and d. Paris
1704–78), Paris, 1771, signed and dated**
Marble, *H* 76.5 cm
Marie Antoinette was the daughter of the
Empress Maria Theresa, born 1755, married
1770 to the Dauphin, who was later to become
King Louis XVI of France. She was guillotined
in 1793.
Present from King Louis XV of France to the
Empress Maria Theresa in 1772. (5478)

▽

PIECES FROM THE BREAKFAST SERVICE OF THE
EMPRESS MARIA THERESA
**Anton Matthias Domanek (b. and d. Vienna
1713–79), Vienna, mid-18th century**
Gold, ebony, porcelain
Behind, left to right: coffee pot, *H* 14 cm, (1207);
warming-dish with water jug, *Diam* 35.4 cm,
H of jug 20.3 cm (1199 and 1249); milk jug, *H*
23.4 cm (1260)
In front: Chocolate mug and stand, sugar basin
on a stand, spatula, tea bowl and saucer,
spoon.
Presented to the Treasury in 1781.

SCENES FROM THE NOVEL *DON QUIXOTE*: LADIES
WAITING ON DON QUIXOTE
**Paris Gobelins (State Tapestry Factory);
weaver Jacques Neilson (1749–88), 1781,
signed and dated; after designs by Charles
Antoine Coypel (1694–1756) of 1714–15**
Wool and silk tapestry; 369 × 513 cm
Present from King Louis xvi to Archduke
Ferdinand, Governor of Lombardy, on the
occasion of the latter's visit to Paris in 1786.
Taken over from the Este Collection. (cxv/1)

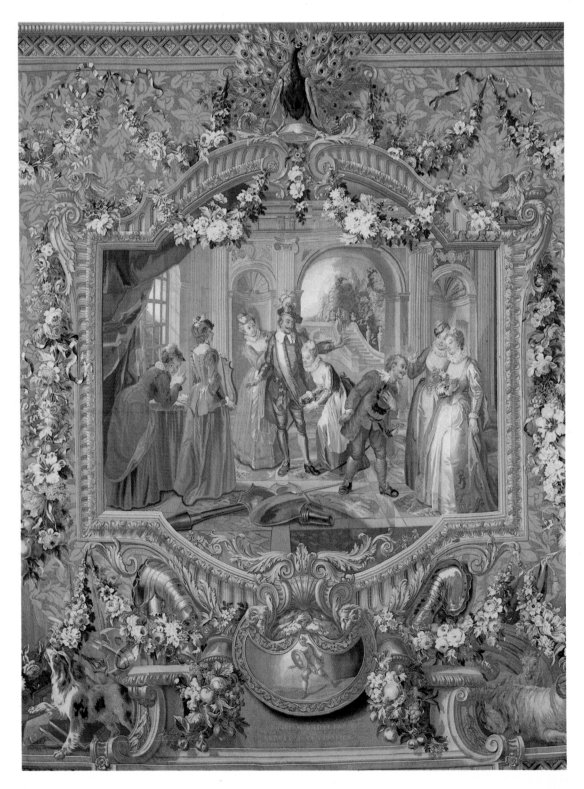